Thoreau's Maine Woods

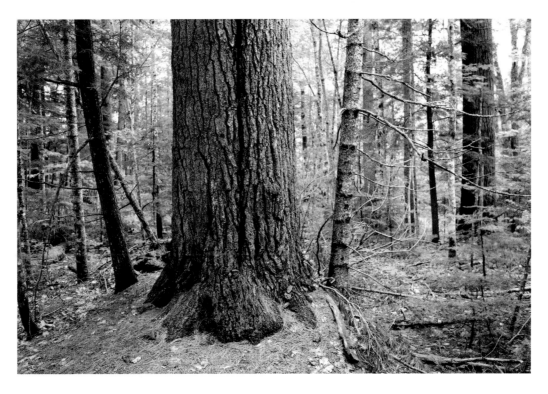

photography by

Dan Tobyne

ISBN: 978-0-89272-814-5

Design by Miroslaw Jurek

Printed in China

Library of Congress Cataloging-in-Publication Data:
Thoreau, Henry David, 1817-1862.
 [Maine woods. Selections]
 Thoreau's Maine woods / photography by Dan Tobyne ; introduction by Bernd
Heinrich.
 p. cm.
 ISBN 978-0-89272-814-5 (trade hardcover : alk. paper)
 1. Piscataquis County (Me.)--Description and travel. 2.
Maine--Description and travel. 3. Thoreau, Henry David,
1817-1862--Travel--Maine. 4. Authors, American--19th century--Biography. 5.
Maine--Pictorial works. 6. Landscape--Maine--Pictorial works. 7. Thoreau,
Henry David, 1817-1862--Travel--Maine--Pictorial works. I. Tobyne, Dan. II.
Title.
 F27.P5T432 2010
 974.1'25--dc22
 2009041756

DownEastBooks
www.nbnbooks.com

Distributed to the trade by National Book Network

*In wildness
is the preservation
of the world.*

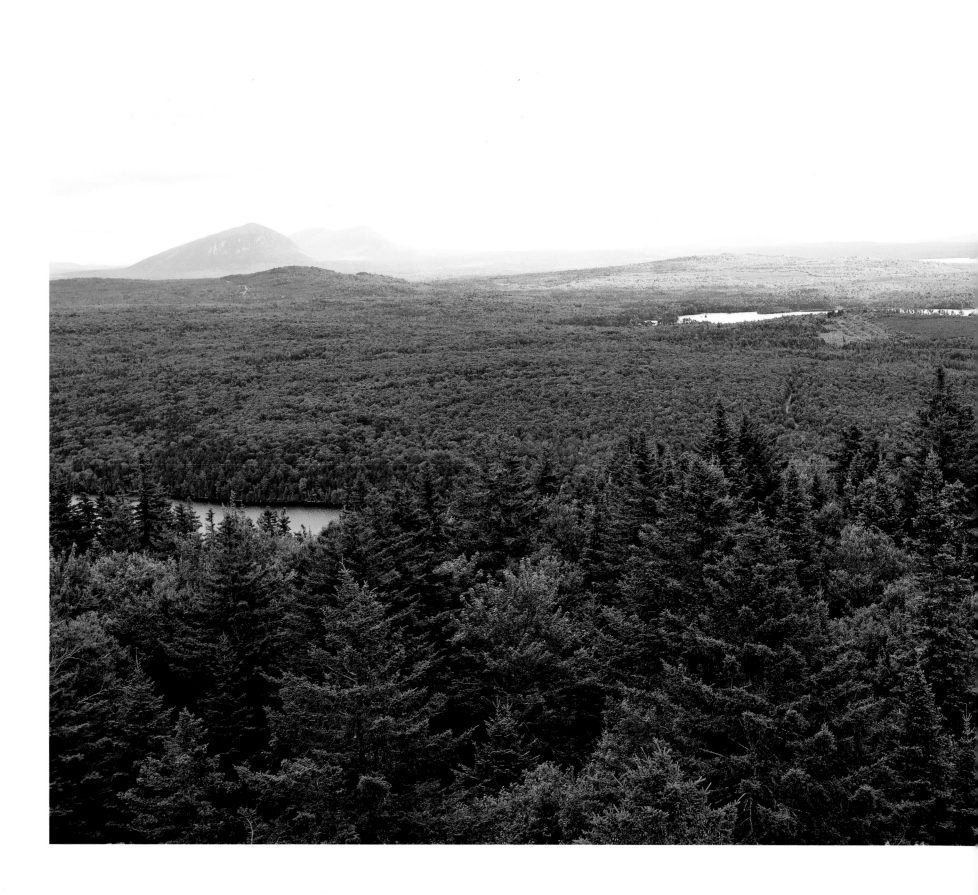

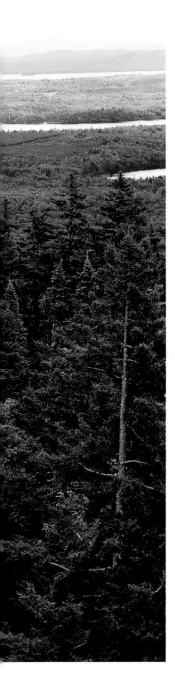

Introduction

BY BERND HEINRICH

"Moose . . . Indians . . ." were the last words from Henry David Thoreau's lips when he died in his native Concord, Massachusetts, on May 6, 1862. He had (in 1851) penned the now immortal words, "in wildness is the preservation of the world," and as he looked back at the end of his journey, he saw where he had been. He had been to the Maine woods, from where he had earlier looked ahead; he had transcended his own existence and would leave an indelible imprint on the world that will survive the ages.

He had lived all 44 years of his life in Concord, but he had made three trips to Maine (in 1846, 1853, and 1857), and that is where his heart and soul were, and remained to his last breaths. Just before he consulted his memory and saw moose and Indians on that day in early May he said, "Now comes good sailing." He was probably thinking of the Maine woods. He had said of them, "What a place to live, what a place to die and be buried in! There certainly men would live forever, and laugh at death and the grave." Was he thinking of Umbazookskus, which "the Indian said [was] a dead stream with broad meadows, [that was] a good place for moose?" Maybe he was recalling the West Branch of the Penobscot River, where he awakened one midnight "to watch the grotesque and fiend-like forms and motions of some of the party, who, not being able to sleep, had got up silently to arouse the fire . . . Thus aroused, I . . . rambled along the sandy shore in the moonlight, hoping to meet a moose, come down to drink, or else a wolf." Although he did not laugh at the grave, he certainly did not fear it. When asked as he lay dying if he had made his peace with God, he replied: "I did not know we ever quarreled."

All of these may strike some as strange words from a man who grew up and lived all his life in and at the edge (within a mile and a half, for two years at Walden Pond) of Concord. Given that background, it is hard to imagine him ever becoming a wilderness acolyte, much less an original philosopher, if not for his trips to Maine. After attending Harvard he continued to be bound to the genteel intellectual influence, first through Ralph Waldo Emerson, who took him under his wing and allowed him to move in with him in 1841. It was Emerson who introduced him to nature writing, and to a coterie of local intellectuals. He taught school with his brother

John, until he was dismissed from Concord Academy after refusing to administer corporal punishment. There, he and John had initiated something new: Contact; they took nature walks with their students.

He worked then in his family pencil factory, but wanted to buy a farm where he could retire to write. Instead, he built a small cabin on land that Emerson owned at the edge of Walden Pond. He did write then—while grieving over the death of John, who had died from a tetanus infection contracted through a cut while shaving (Henry maintained a beard)—on a draft of *A Week on the Concord and Merrimack Rivers*. If Henry, rather than John, had nicked his chin the world as we know it might be a different place. While at Walden Pond from July 4, 1845 to September 6, 1847, where he grew a few beans and lived a simple life, he maintained almost daily contact with his mother, who supplied him with treats. But he read widely of explorers to far-off places, including Charles Darwin aboard the *Beagle*, Captain Cook in the Pacific, Franklin in the Arctic, Richard Burton in Africa, and Lewis and Clark in the American west. It is ironic that some of his critics have accused Thoreau's idea of simple living of being a retreat from the world and a wanting to "lower himself to the level of a woodchuck," if not of being downright "wicked and heathenish."

As he became older in his all too short life, Thoreau became ever more restless and interested in natural history, and nature beckoned him. In part he received more nature contact by becoming a land surveyor, and to him nature soon represented the wild. "Live at home like a traveler," one of his aphorisms, may have been his sour grapes for not being able to go physically to the far-off lands he read about. But Maine was at his doorstep, and to his life in Concord, where everything was settled, cut-over, and cultivated, it represented the wild. It must have appealed to his unfulfilled experiences of wildness at Walden.

In Maine Thoreau recognized that our home is more than where our body resides. It is also where our soul resides. Maine was the home of my soul within a month of my arrival here sixty years ago. I feel that I know what he was talking about, although it is not anything I can specify objectively as representing the whole of reality. Yet, what he felt and described, his Maine, is also the home of millions of people all over the globe. It is but a room in the home that is now the whole world, made one by common culture, language, customs, jet travel, and instant electronic communication that makes it possible to talk and see each other in real time, no matter where our bodies may reside. These same marvels, supported and made possible because of our global economy, are at the same time destroying the wild places and making the fast-shrinking homes of our souls into sinking islands in a sea of progress.

Thoreau saw in the backwoods cabins and life in Maine that "most of the luxuries and many of the so-called comforts of life are not only indispensable, but positive hindrances to the elevation of mankind." They only masked

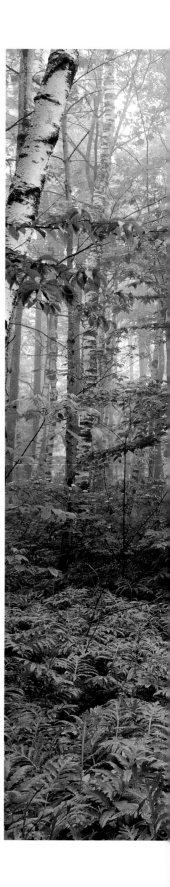

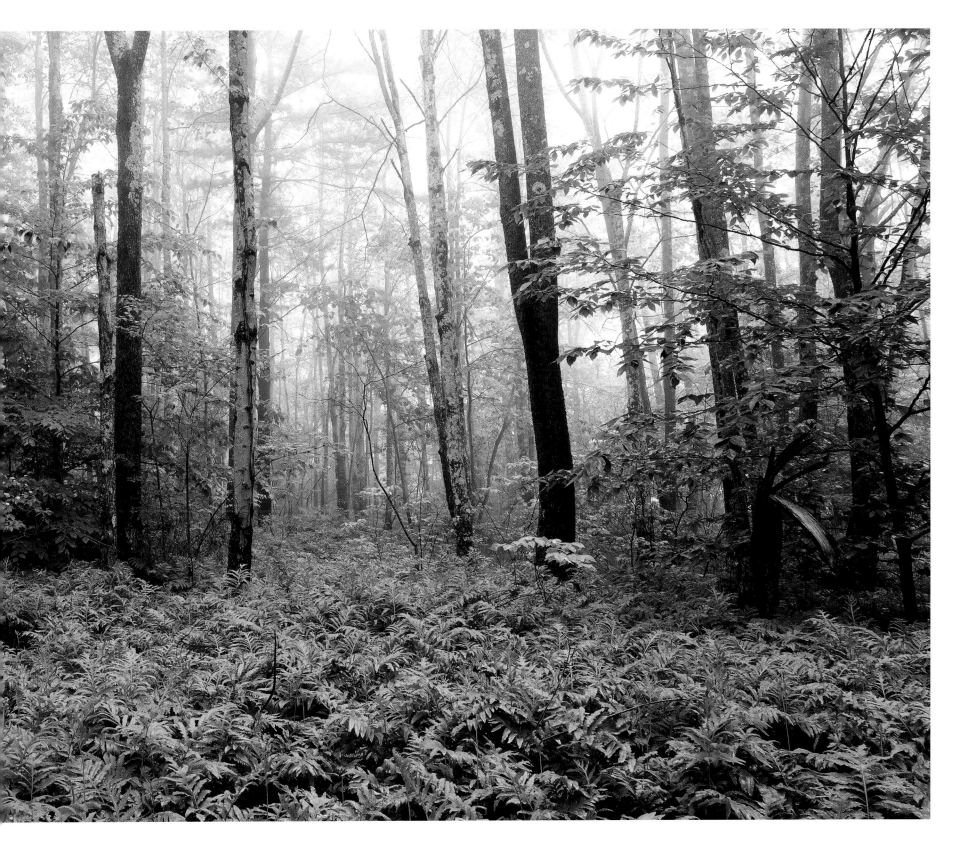

life's true essential needs. So it is not surprising that he put it this way: "The greater part of what my neighbors call good I believe in my soul to be bad, and if I repent of anything, it is very likely to be my good behavior. What demon possessed me that I behaved so well!" Strong words, for a man known for his ornery contrariness.

Almost a century and a half have passed since Thoreau visited the Maine woods and made them the home of his soul. One has to wonder what he would think and how he would behave now. He was then already fearing that they might become, like his native Concord and the rest of New England, degraded by commercial enterprise, which in his case he could only envision as the cutting down of great pine trees. Trees re-grow. Moose and deer can thrive in the face of hunting pressure, as they have for millions of years. Indeed, despite his affections for the prey, he also had a grudging respect if not romantic inclination to the predators, the hunters, loggers, and woodsmen. He had balanced (some would say contradictory) views that above all respected individual rights.

Today, the Maine woods are in danger of ever-greater changes, permanent and irreversible ones. It is now more than ever imperative that we see them again as Thoreau did, as a home of humanity, as a retreat of the mind to make and keep us human and rooted in the nature that is our biological heritage. What would he think of international collectives connected by commercial interests only, who erect housing developments in the middle of the wilderness, and who would violate the sanctity of mountains and lakes so they can make a buck? What chance does an individual have against them who have grown so monstrous? None. Only the government has the power to stand up for individuals of the Maine woods. What, dear Henry, since you said, "that government is best which governs not at all," do you think of government now, if it alone can stand in defense of your spiritual home? Against whom should your, and our, civil disobedience be aimed?

The prevailing paradigm is economic growth. It is "the good" that those of influence and power feel now, and it is "the bad" that those who look ahead see. Given that the immediate global interests are and will continue to be economic growth, our only bulwark is to foster awareness, to try to save what we have. The legacy of Thoreau is in his view of the larger picture, the one that sees value beyond commerce. In Maine we still have some of the wilderness he saw as having the power to awaken the soul and to save the world. Let all the world see his woods. Let all the world enjoy them and feel refreshed and inspired, as they inspired one of the greatest social revolutionaries who ever lived. The pictures in this book are a tribute to his vision.

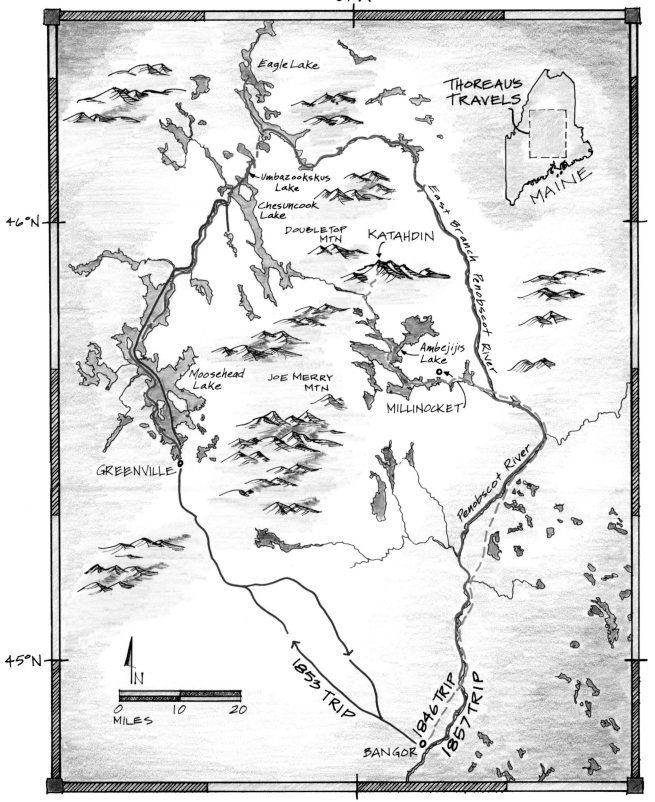

69°W

THOREAU'S
TRAVELS

MAINE

Eagle Lake

Umbazookskus
Lake

Chesuncook
Lake

46°N

DOUBLETOP
MTN

KATAHDIN

East Branch Penobscot River

Ambejijis
Lake

Moosehead
Lake

JOE MERRY
MTN

MILLINOCKET

GREENVILLE

Penobscot River

45°N

N

0 10 20
MILES

1853 TRIP

1846 TRIP

1857 TRIP

BANGOR

From this elevation, just on the skirts of the clouds, we could overlook the country, west and south, for a hundred miles. There it was, the State of Maine, which we had seen on the map, but not much like that, —immeasurable forest for the sun to shine on, that eastern stuff we hear of in Massachusetts. No clearing, no house. It did not look as if a solitary traveller had cut so much as a walking-stick there. Countless lakes, —Moosehead in the southwest, forty miles long by ten wide, like a gleaming silver platter at the end of the table; Chesuncook, eighteen long by three wide, without an island; Millinocket, on the south, with its hundred islands; and a hundred others without a name; and mountains also, whose names, for the most part, are known only to the Indians. The forest looked like a firm grass sward, and the effect of these lakes in its midst has been well compared, by one who has since visited this same spot, to that of a "mirror broken into a thousand fragments, and wildly scattered over the grass, reflecting the full blaze of the sun." It was a large farm for somebody, when cleared.

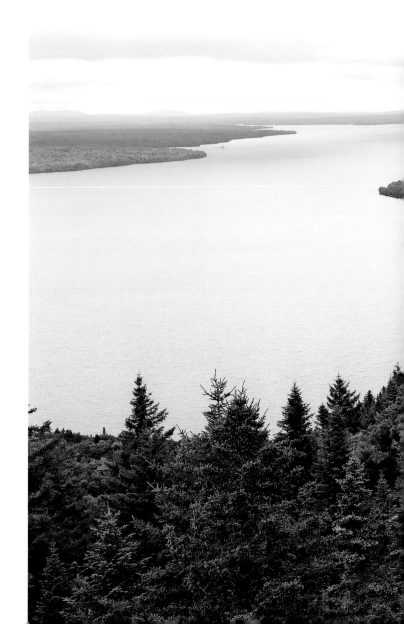

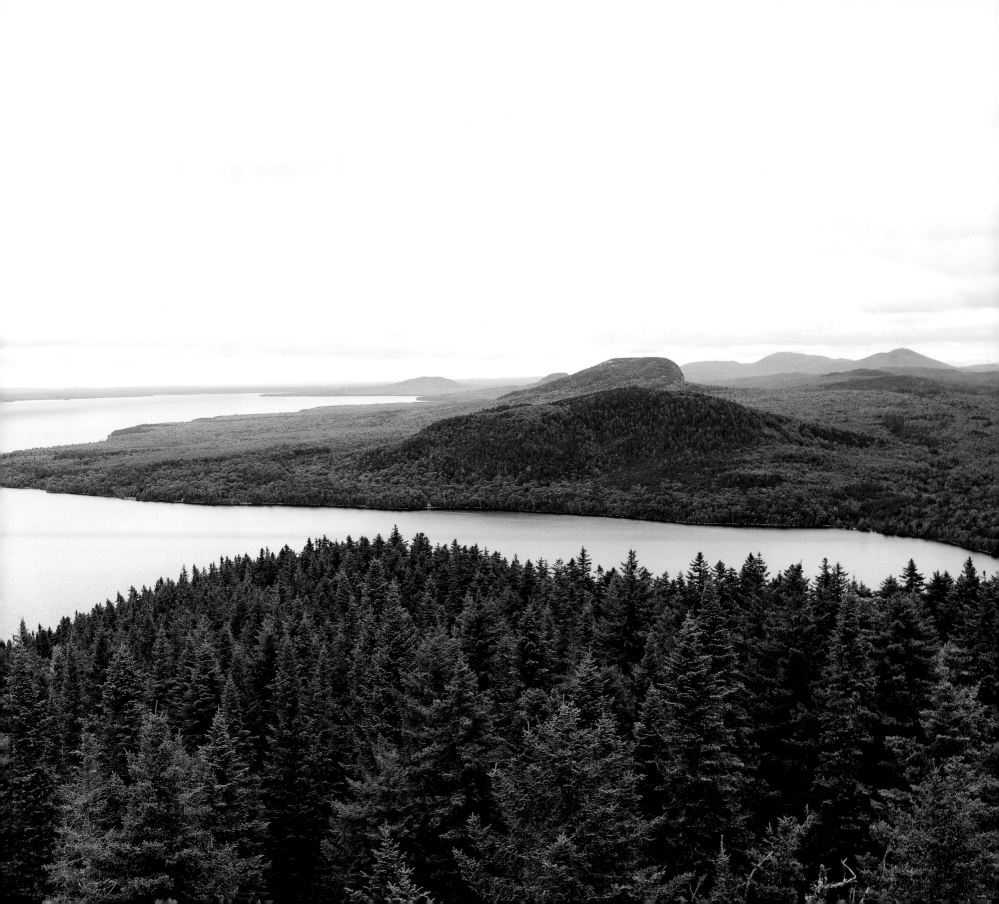

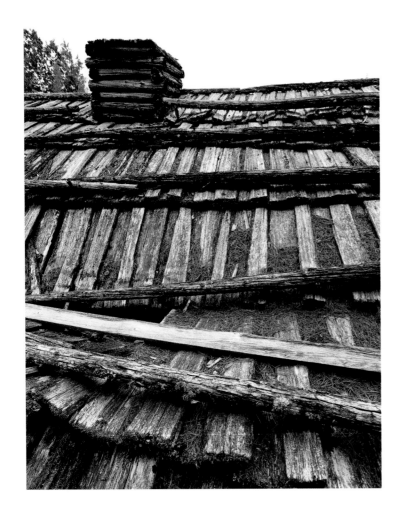

These houses are made comfortable by the huge fires, which can be afforded night and day. Usually the scenery about them is drear and savage enough; and the loggers' camp is as completely in the woods as a fungus at the foot of a pine in a swamp; no outlook but to the sky overhead; no more clearing than is made by cutting down the trees of which it is built, and those which are necessary for fuel. If only it be well sheltered and convenient to his work, and near a spring, he wastes no thought on the prospect. They are very proper forest houses, the stems of the trees collected together and piled up around a man to keep out wind and rain,—made of living green logs, hanging with moss and lichen, and with the curls and fringes of the yellow-birch bark, and dripping with resin, fresh and moist, and redolent of swampy odors, with that sort of vigor and perennialness even about them that toadstools suggest.

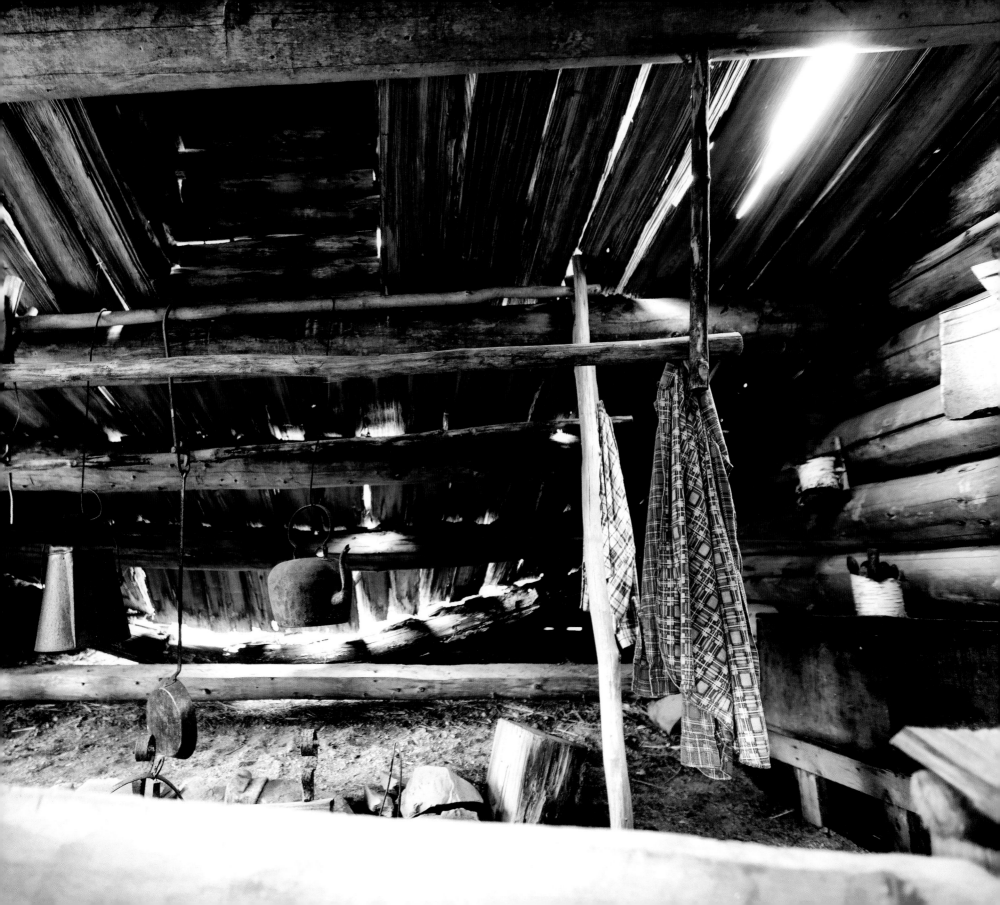

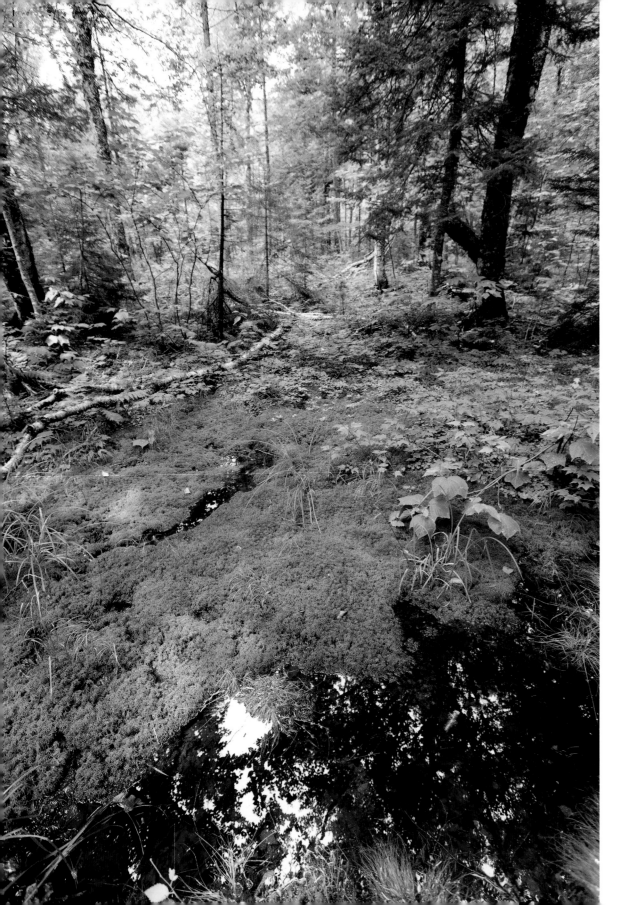

The primitive wood is always and everywhere damp and mossy, so that I travelled constantly with the impression that I was in a swamp; and only when it was remarked that this or that tract, judging from the quality of the timber on it, would make a profitable clearing, was I reminded, that if the sun were let in it would make a dry field, like the few I had seen, at once. The best shod for the most part travel with wet feet. If the ground was so wet and spongy at this, the dryest part of a dry season, what must it be in the spring?

At first we lay awake, talking of our course, and finding ourselves in so convenient a posture for studying the heavens, with the moon and stars shining in our faces, our conversation naturally turned upon astronomy, and we recounted by turns the most interesting discoveries in that science.

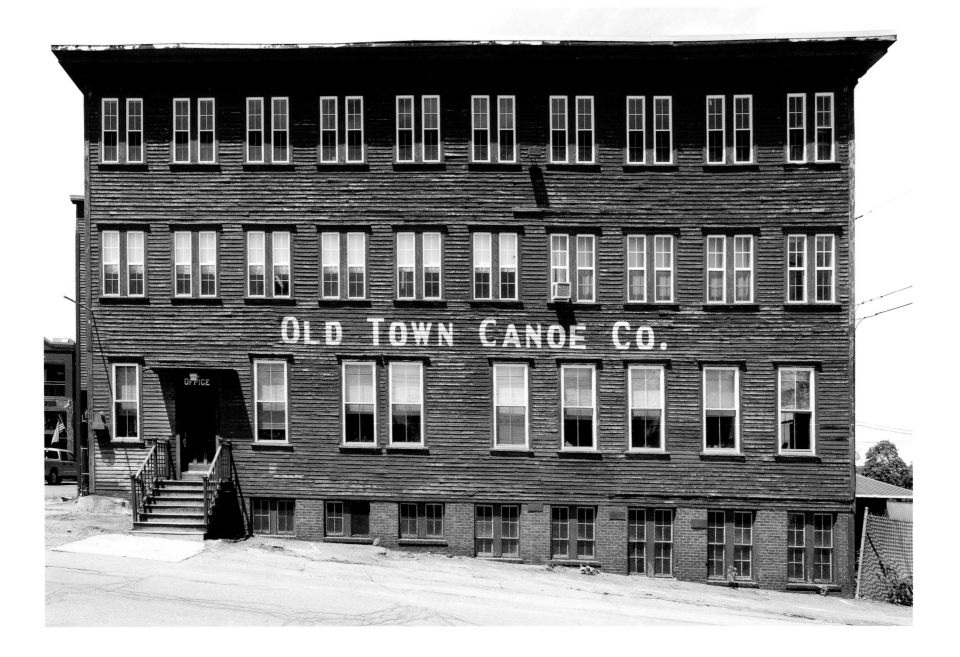

At Old Town we walked into a batteau-manufactory. The batteau is a sort of mongrel between the canoe and the boat, a fur-trader's boat. The making of batteaux is quite a business here for the supply of the Penobscot River. We examined some on the stocks. They are light and shapely vessels, calculated for rapid and rocky streams, and to be carried over long portages on men's shoulders, from twenty to thirty feet long, and only four or four and a half wide, sharp at both ends like a canoe, though broadest forward on the bottom, and reaching seven or eight feet over the water, in order that they may slip over rocks as gently as possible.

There was something refreshing and wildly musical to my ears in the very name of the white man's canoe, reminding me of Charlevoix and Canadian Voyageurs.

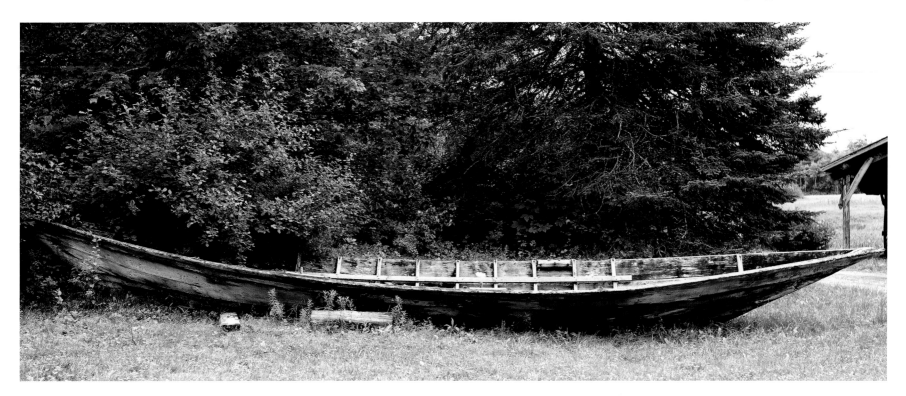

Now and then we passed what McCauslin called a pokelogan, an Indian term for what the drivers might have reason to call a poke-logs-in, an inlet that leads nowhere. If you get in, you have got to get out again the same way. These, and the frequent "run-rounds" which come into the river again, would embarrass an inexperienced voyager not a little.

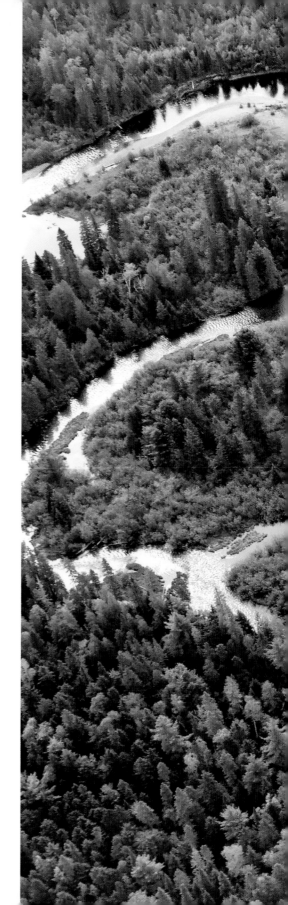

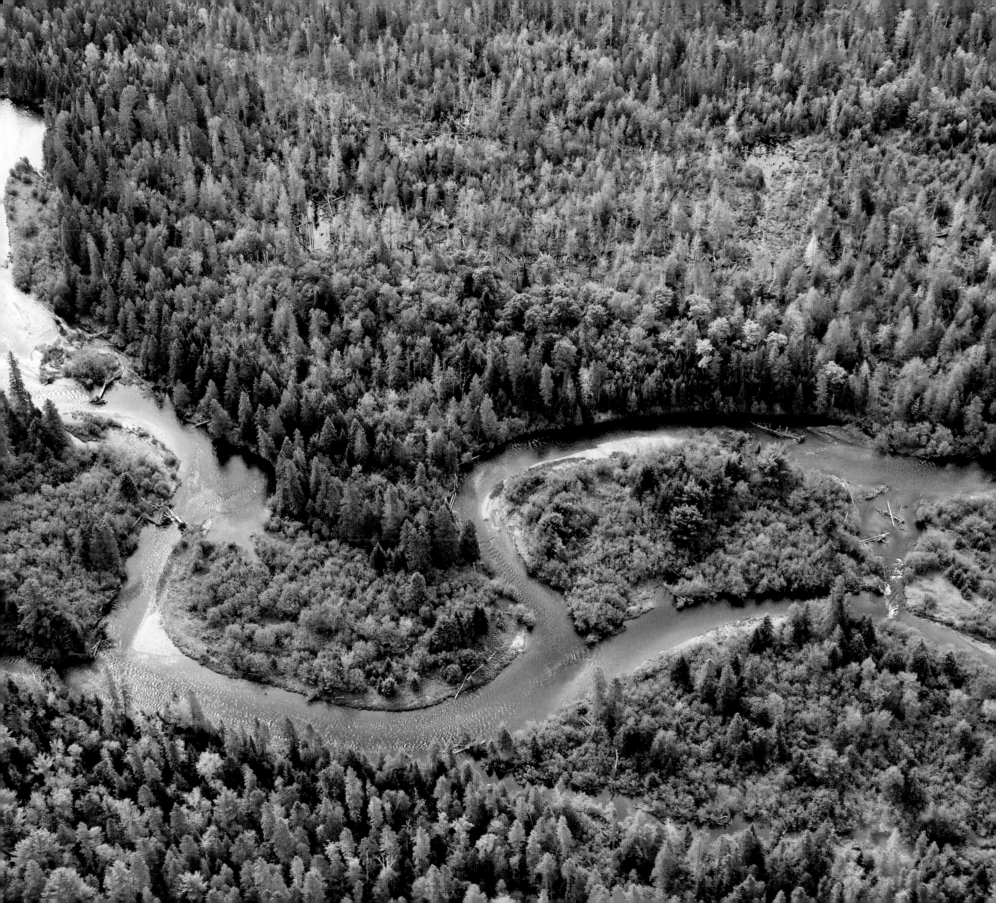

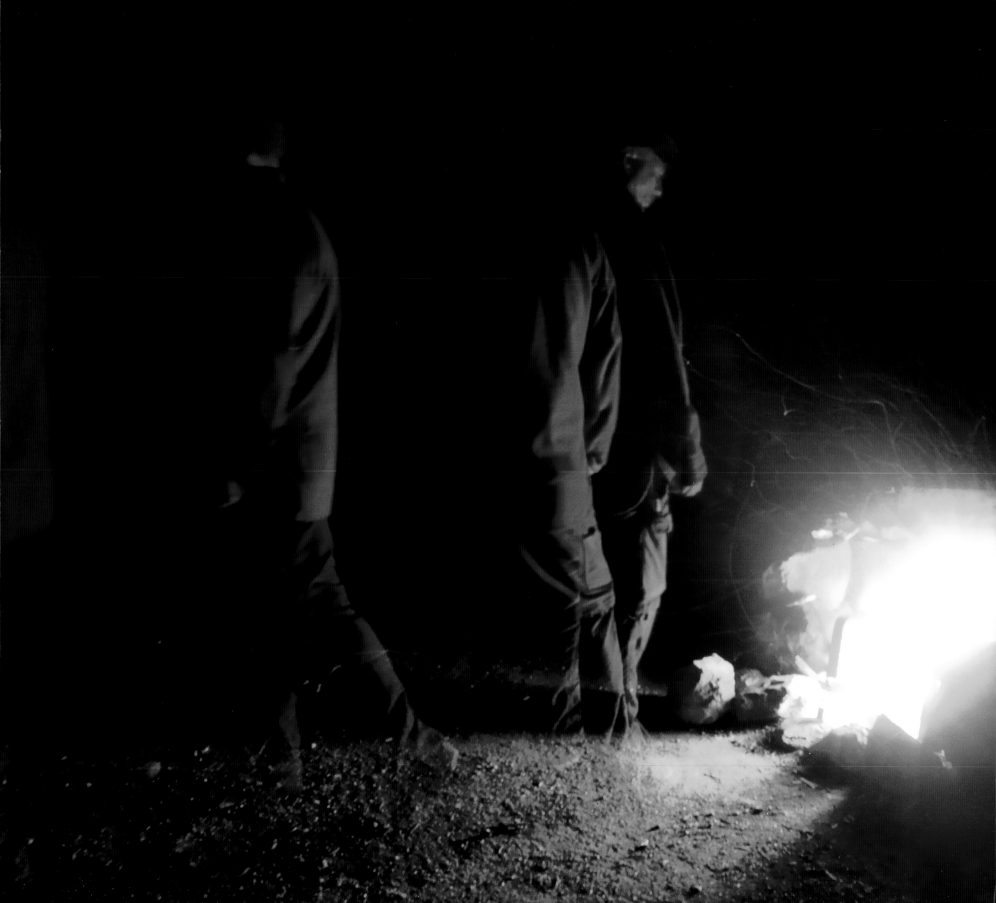

It was interesting, when awakened at midnight, to watch the grotesque and fiend-like forms and motions of some one of the party, who, not being able to sleep, had got up silently to arouse the fire, and add fresh fuel, for a change; now stealthily lugging a dead tree from out the dark, and heaving it on, now stirring up the embers with his fork, or tiptoeing about to observe the stars, watched, perchance, by half the prostrate party in breathless silence; so much the more intense because they were awake, while each supposed his neighbor sound asleep. Thus aroused, I too brought fresh fuel to the fire, and then rambled along the sandy shore in the moonlight, hoping to meet a moose, come down to drink, or else a wolf.

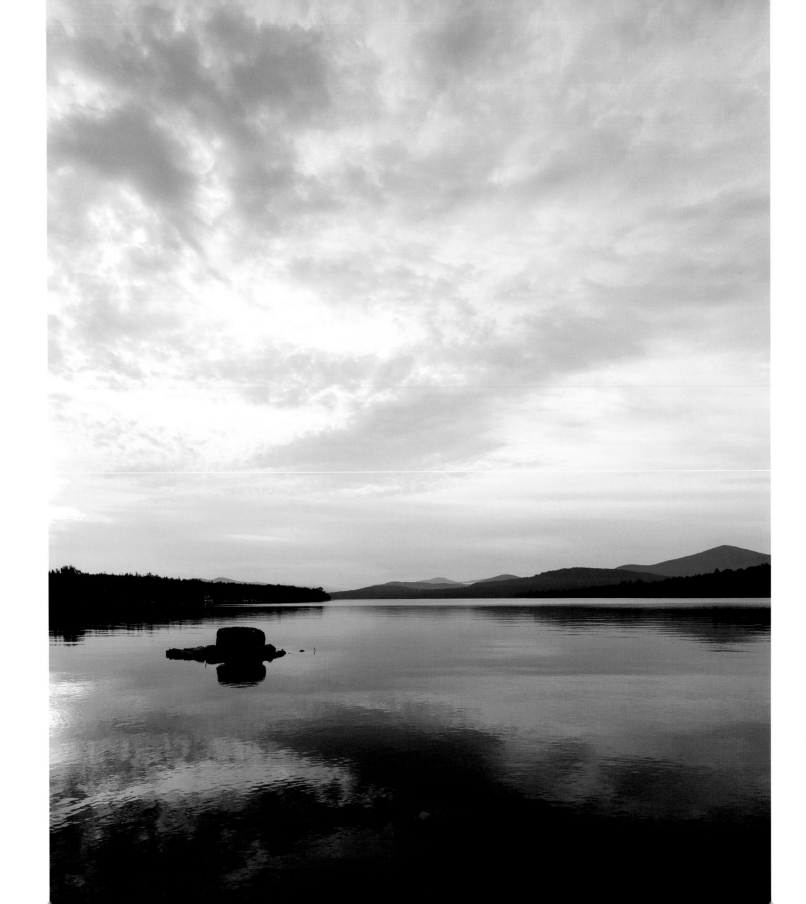

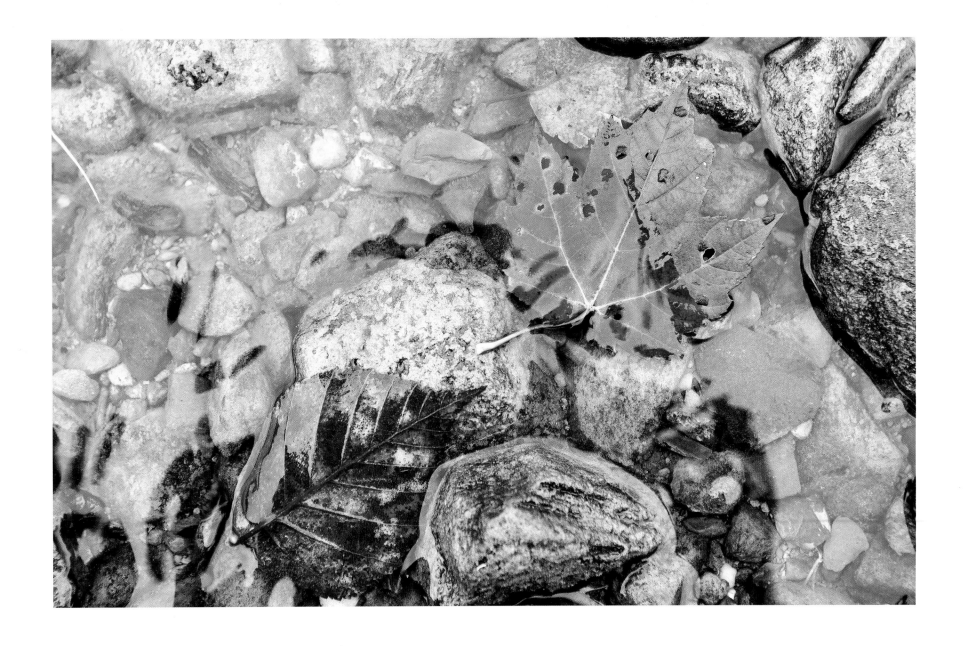

The little rill tinkled the louder, and peopled all the wilderness for me; and the glassy smoothness of the sleeping lake, laving the shores of a new world, with the dark, fantastic rocks rising here and there from its surface, made a scene not easily described. It has left such an impression of stern, yet gentle, wildness on my memory as will not soon be effaced.

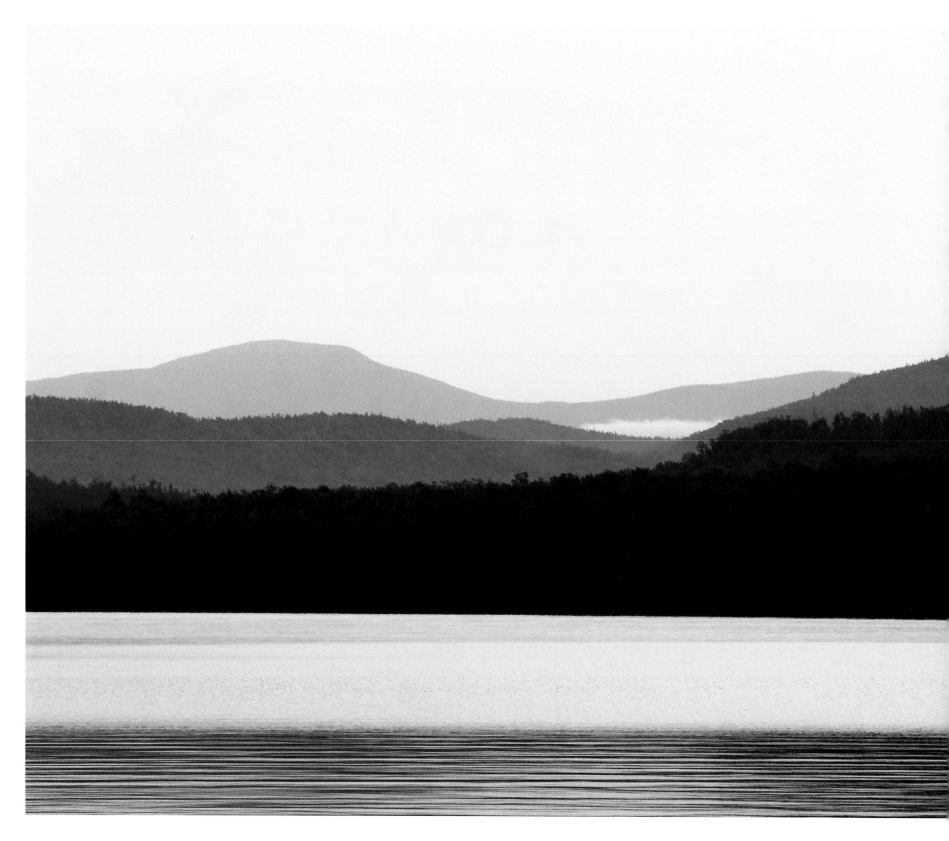

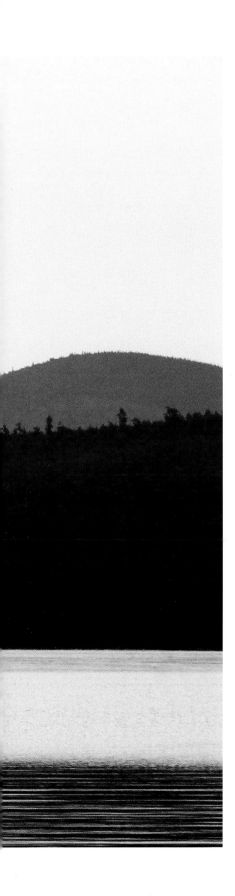

Ambejijis, this quiet Sunday morning, struck me as the most beautiful lake we had seen. It is said to be one of the deepest. We had the fairest view of Joe Merry, Double Top, and Ktaadn, from its surface. The summit of the latter had a singularly flat, table-land appearance, like a short highway, where a demigod might be let down to take a turn or two in an afternoon, to settle his dinner.

Who shall describe

the inexpressible tenderness and immortal life of

the grim forest, where Nature, though it be mid-

winter, is ever in her spring, where the moss-grown

and decaying trees are not old, but seem to enjoy a

perpetual youth; and blissful, innocent Nature, like

a serene infant, is too happy to make a noise, except

by a few tinkling, lisping birds and trickling rills?

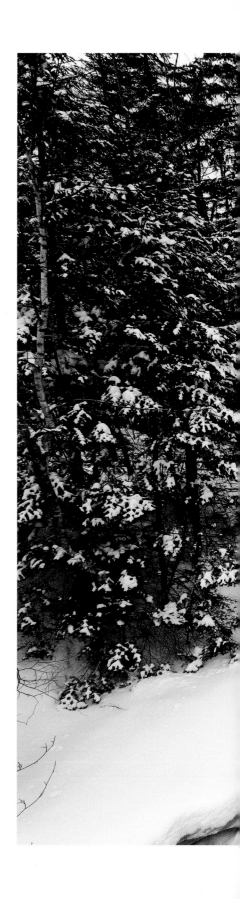

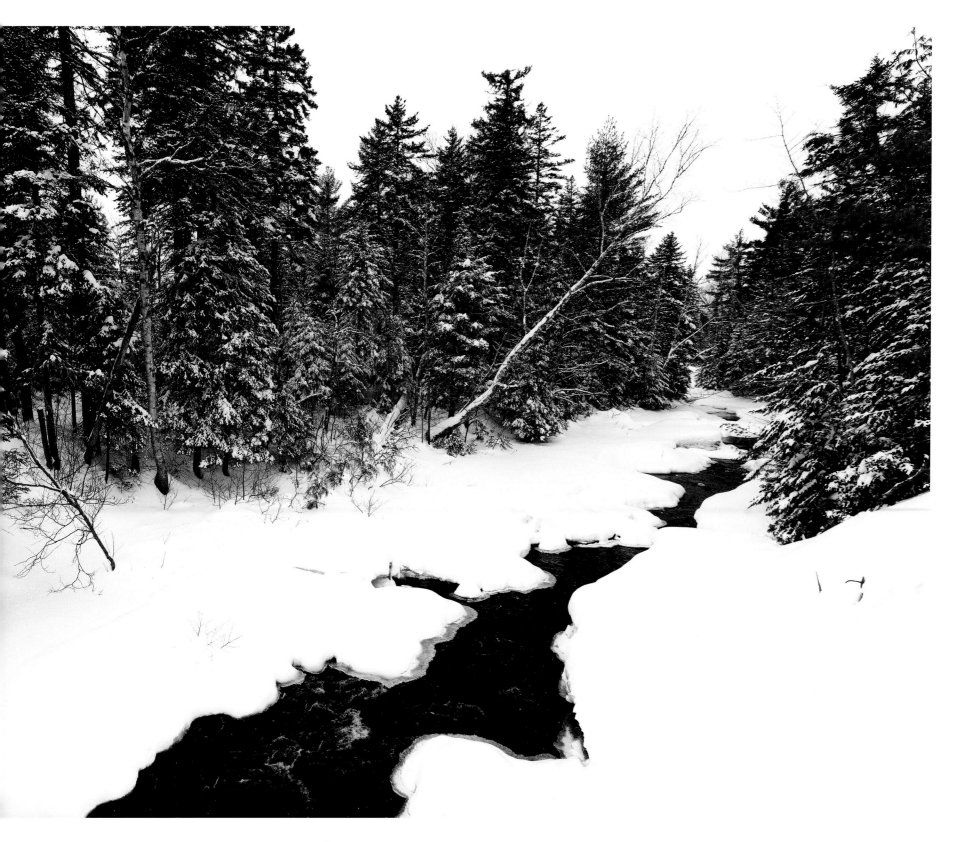

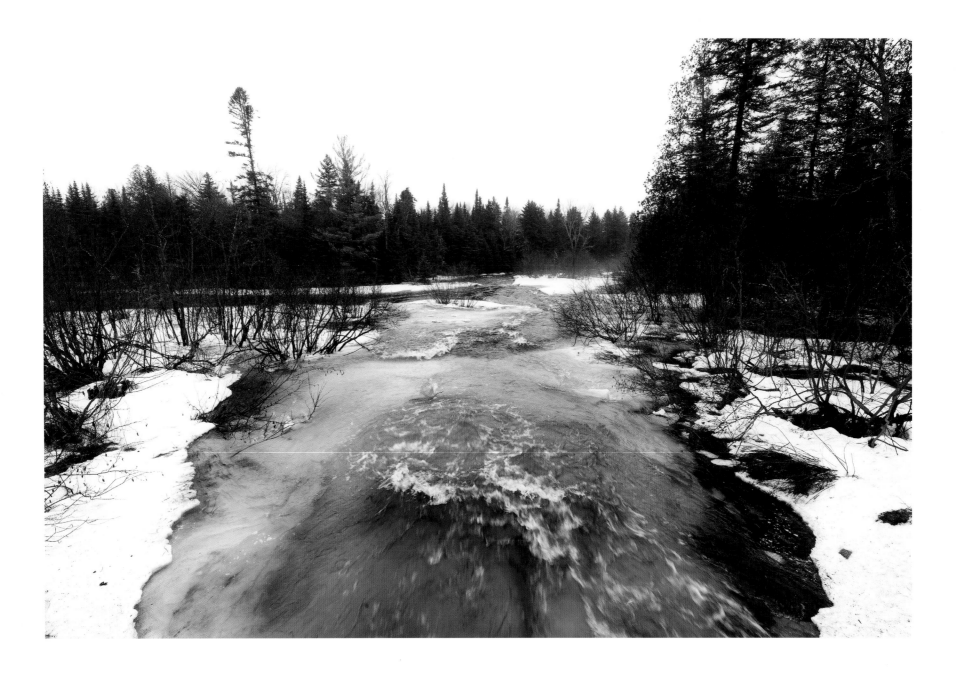

What a place to live, what a place to die and be buried in!
There certainly men would live forever, and laugh at death and the grave.

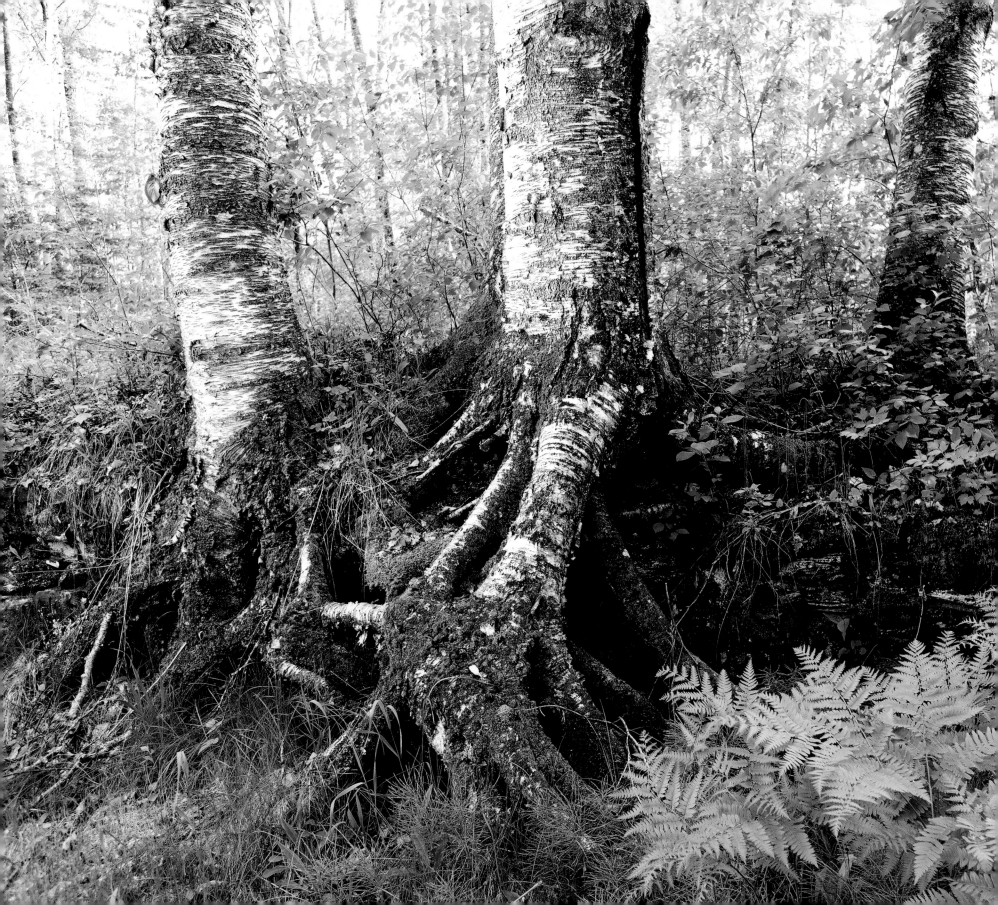

For my dessert, I helped myself to a large slice of the Chesuncook woods, and took a hearty draught of its waters with all my senses. The woods were as fresh and full of vegetable life as lichen in wet weather, and contained many interesting plants; but unless they are of white pine, they are treated with as little respect here as a mildew, and in the other case they are only the more quickly cut down. The shore was of coarse, flat, slate rocks, often in slabs, with the surf beating on it. The rocks and bleached drift-logs, extending some way into the shaggy woods, showed a rise and fall of six or eight feet, caused partly by the dam at the outlet.

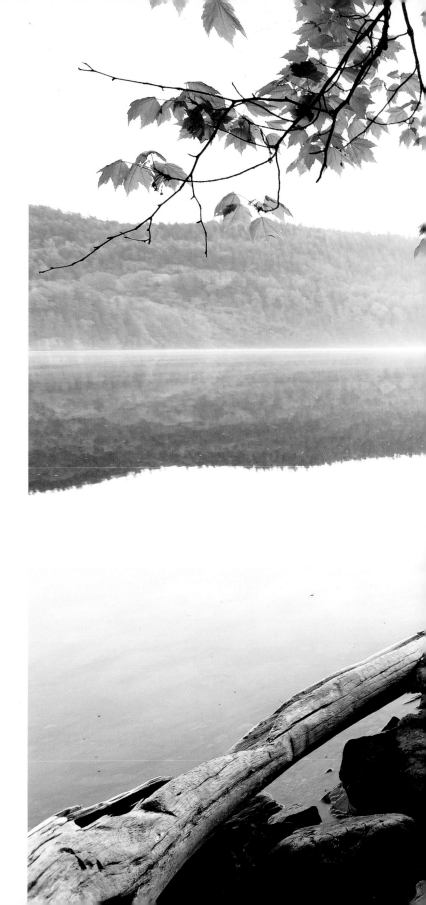

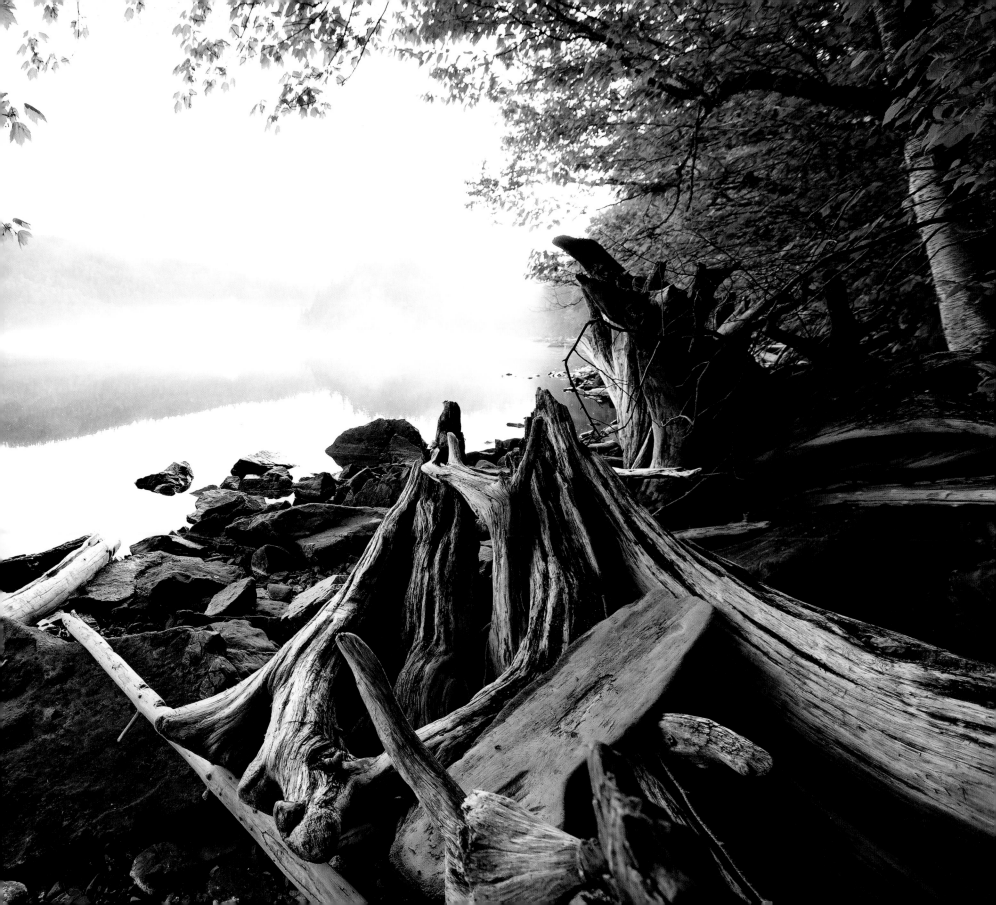

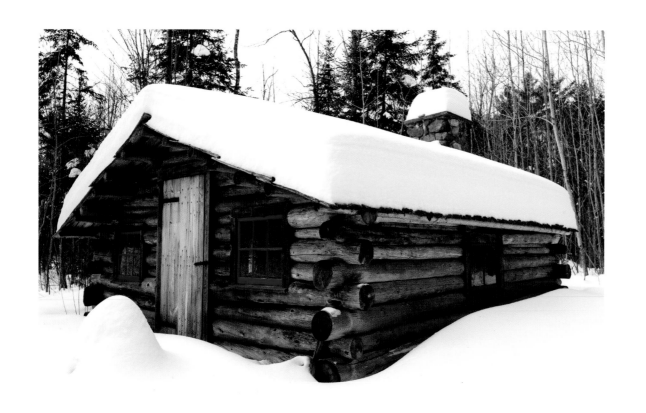

They said that in winter the snow was three feet deep

on a level here, and sometimes four or five, —that the ice on

the lake was two feet thick, clear, and four feet including

the snow-ice. Ice had already formed in vessels.

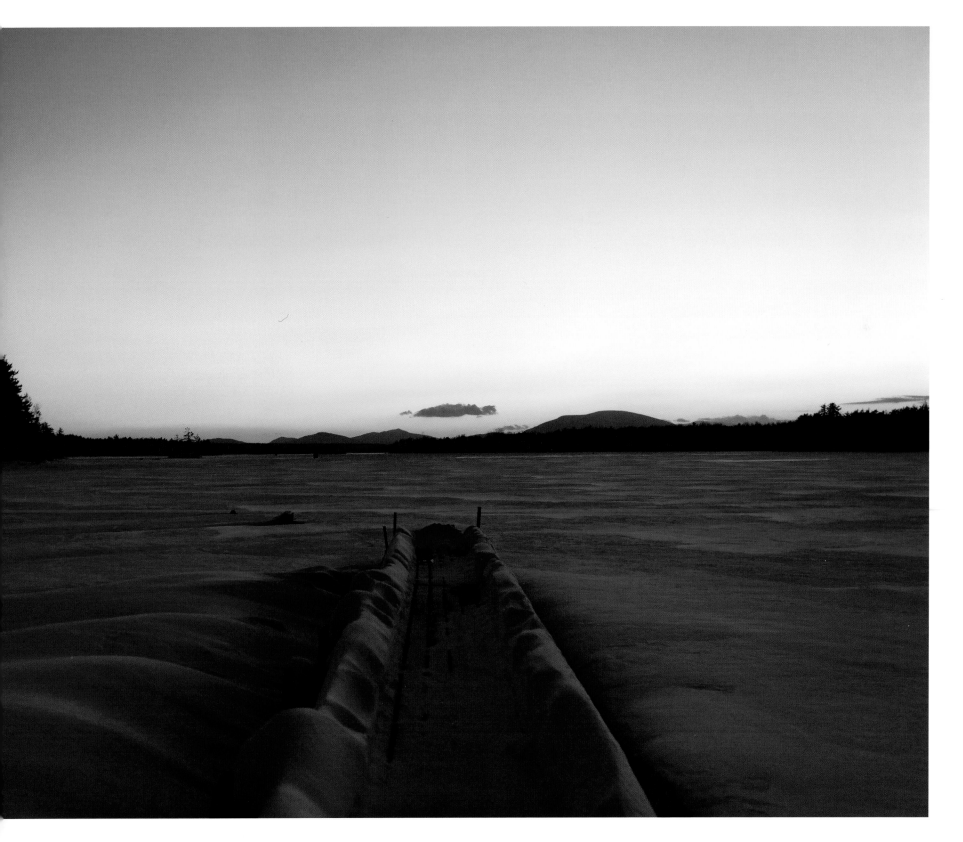

The mountain seemed a vast aggregation of loose rocks, as if some time it had rained rocks, and they lay as they fell on the mountain sides, nowhere fairly at rest, but leaning on each other, all rocking-stones, with cavities between, but scarcely any soil or smoother shelf. They were the raw materials of a planet dropped from an unseen quarry, which the vast chemistry of nature would anon work up, or work down, into the smiling and verdant plains and valleys of earth. This was an undone extremity of the globe; as in lignite, we see coal in the process of formation.

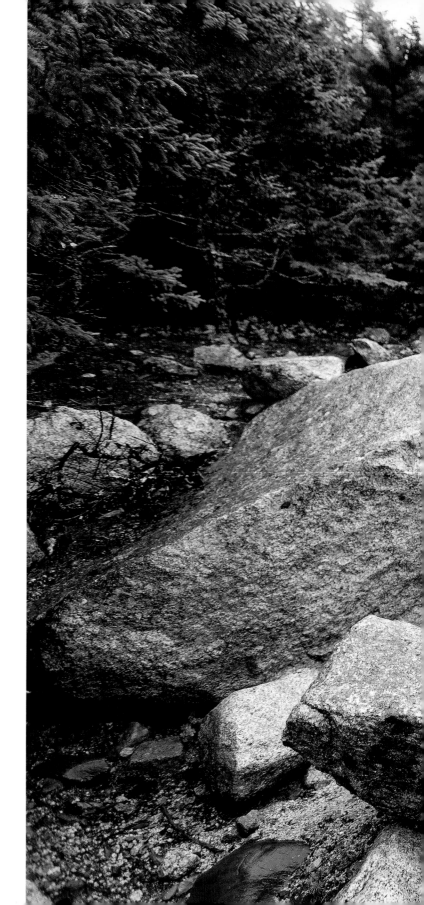

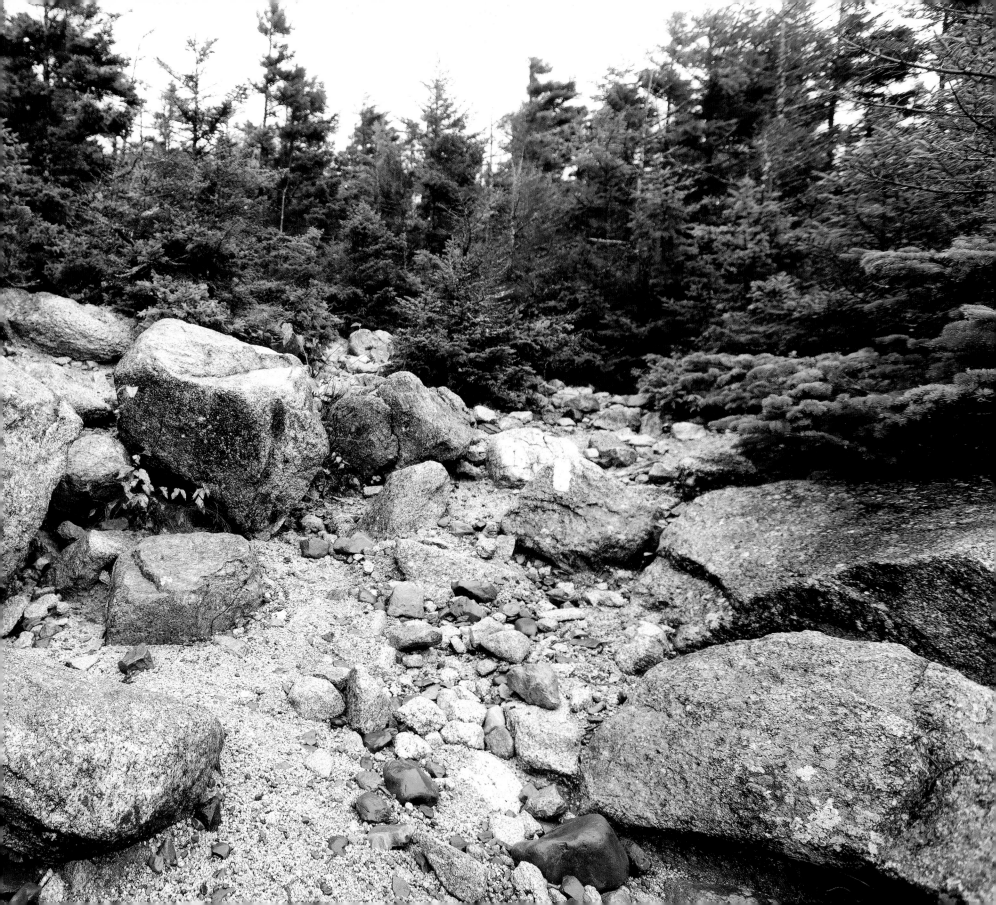

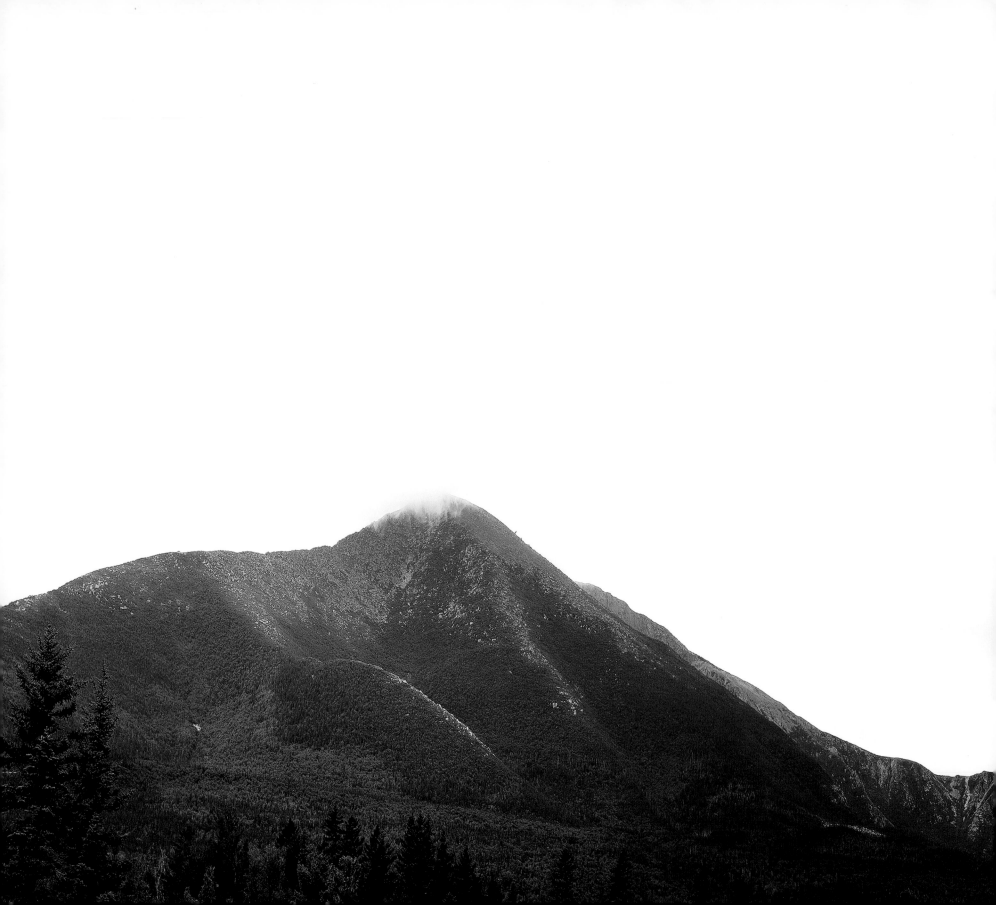

The tops of mountains are among the unfinished parts of the globe, whither it is a slight insult to the gods to climb and pry into their secrets, and try their effect on our humanity. Only daring and insolent men, perchance, go there. Simple races, as savages, do not climb mountains,—their tops are sacred and mysterious tracts never visited by them. Pomola is always angry with those who climb to the summit of Ktaadn.

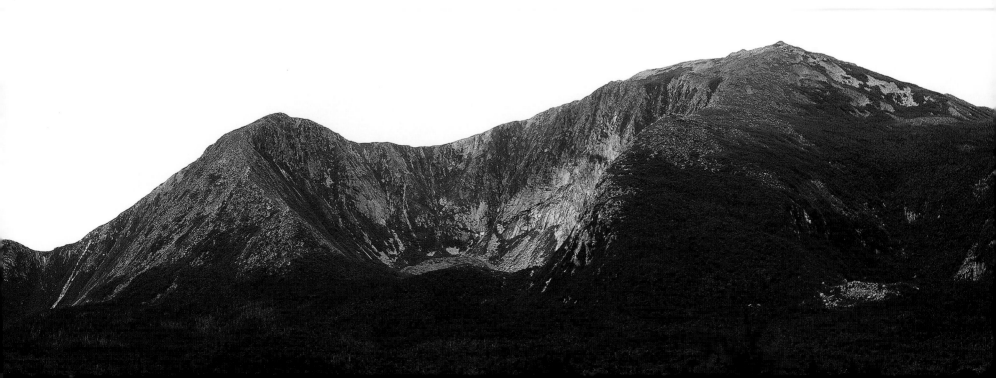

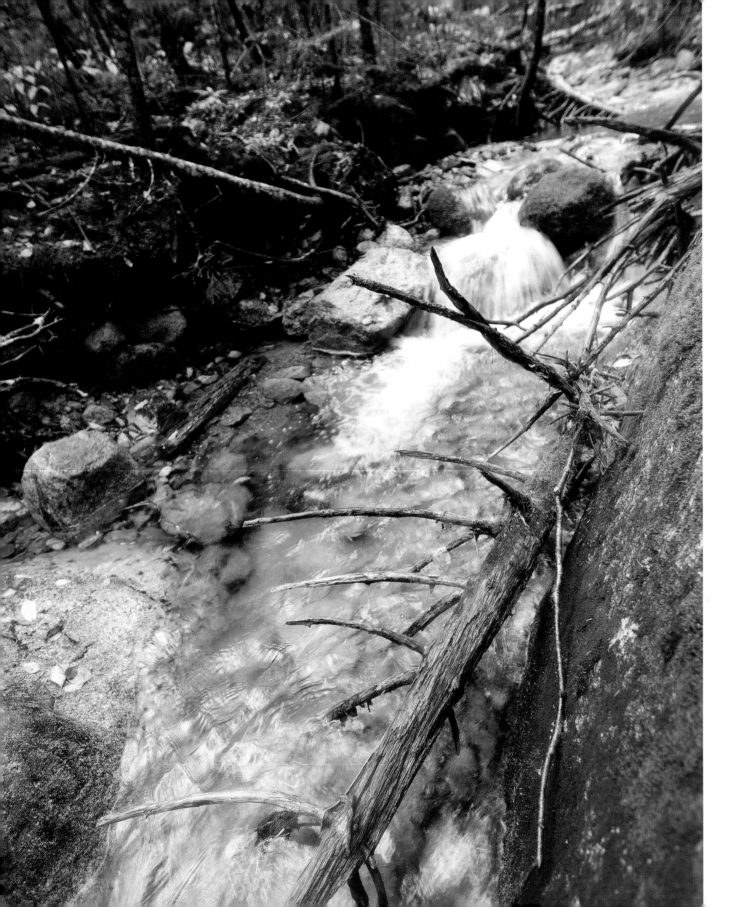

Setting out on our return to the river, still at an early hour in the day, we decided to follow the course of the torrent, which we supposed to be Murch Brook, as long as it would not lead us too far out of our way. We thus travelled about four miles in the very torrent itself, continually crossing and recrossing it, leaping from rock to rock, and jumping with the stream down falls of seven or eight feet, or sometimes sliding down on our backs in a thin sheet of water. This ravine had been the scene of an extraordinary freshet in the spring, apparently accompanied by a slide from the mountain. It must have been filled with a stream of stones and water, at least twenty feet above the present level of the torrent.

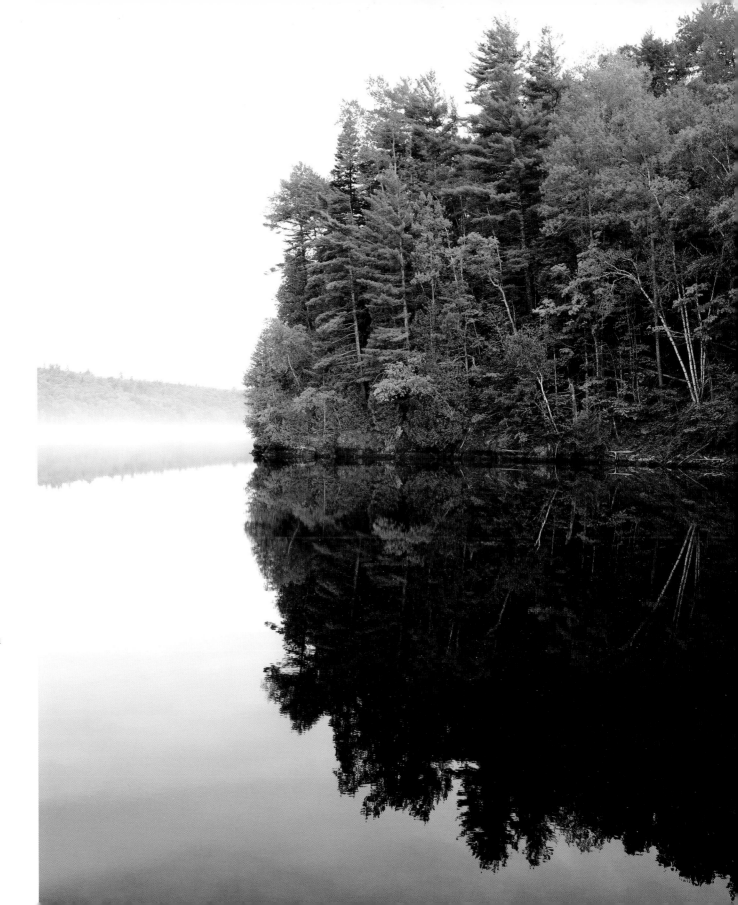

Thus a man shall lead his life away here on the edge of the wilderness, on Indian Millinocket stream, in a new world, far in the dark of a continent, and have a flute to play at evening here, while his strains echo to the stars, amid the howling of wolves; shall live, as it were, in the primitive age of the world, a primitive man. Yet he shall spend a sunny day, and in this century be my contemporary; perchance shall read some scattered leaves of literature, and sometimes talk with me. Why read history, then, if the ages and the generations are now? He lives three thousand years deep into time, an age not yet described by poets. Can you well go further back in history than this?

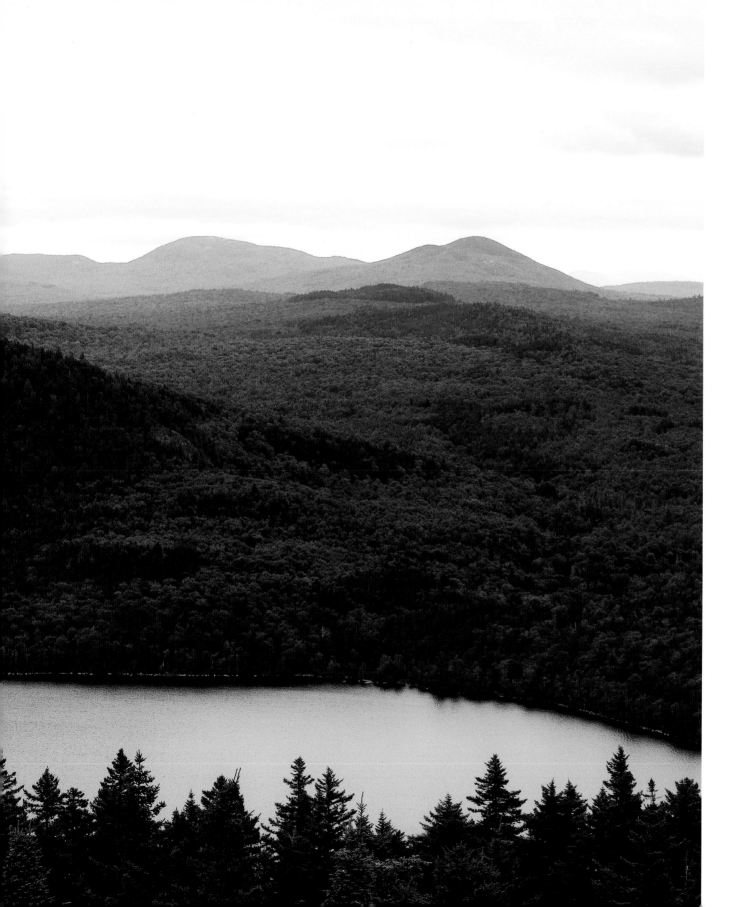

What is most striking in the Maine wilderness is the continuousness of the forest, with fewer open intervals or glades than you had imagined. Except the few burnt-lands, the narrow intervals on the rivers, the bare tops of the high mountains, and the lakes and streams, the forest is uninterrupted. It is even more grim and wild than you had anticipated, a damp and intricate wilderness, in the spring everywhere wet and miry. The aspect of the country, indeed, is universally stern and savage, excepting the distant views of the forest from hills, and the lake prospects, which are mild and civilizing in a degree. The lakes are something which you are unprepared for; they lie up so high, exposed to the light, and the forest is diminished to a fine fringe on their edges, with here and there a blue mountain, like amethyst jewels set around some jewel of the first water,—so anterior, so superior, to all the changes that are to take place on their shores, even now civil and refined, and fair as they can ever be. These are not the artificial forests of an English king,—a royal preserve merely. Here prevail no forest laws but those of nature. The aborigines have never been dispossessed, nor nature disforested.

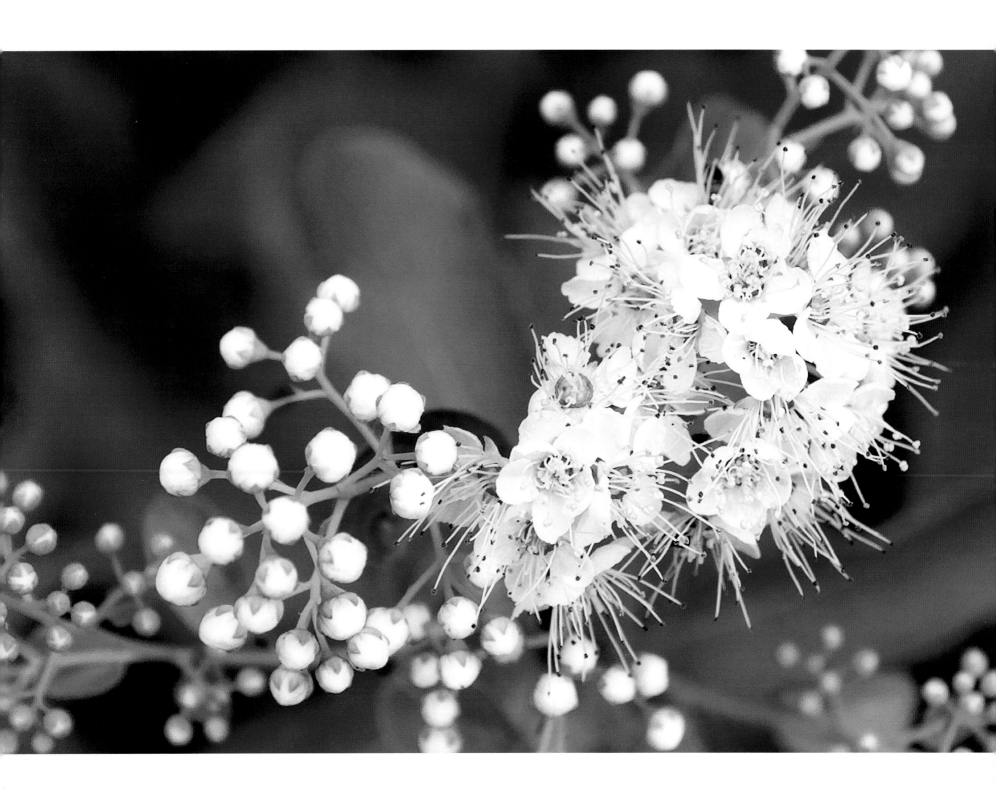

It is a country full of evergreen trees, of mossy silver birches and watery maples, the ground dotted with insipid, small, red berries, and strewn with damp and moss-grown rocks,—a country diversified with innumerable lakes and rapid streams, peopled with trout and various species of leucisci, with salmon, shad, and pickerel, and other fishes; the forest resounding at rare intervals with the note of the chicadee, the blue-jay, and the woodpecker, the scream of the fish-hawk and the eagle, the laugh of the loon, and the whistle of ducks along the solitary streams; at night, with the hooting of owls and howling of wolves; in summer, swarming with myriads of black flies and mosquitoes, more formidable than wolves to the white man. Such is the home of the moose, the bear, the caribou, the wolf, the beaver, and the Indian.

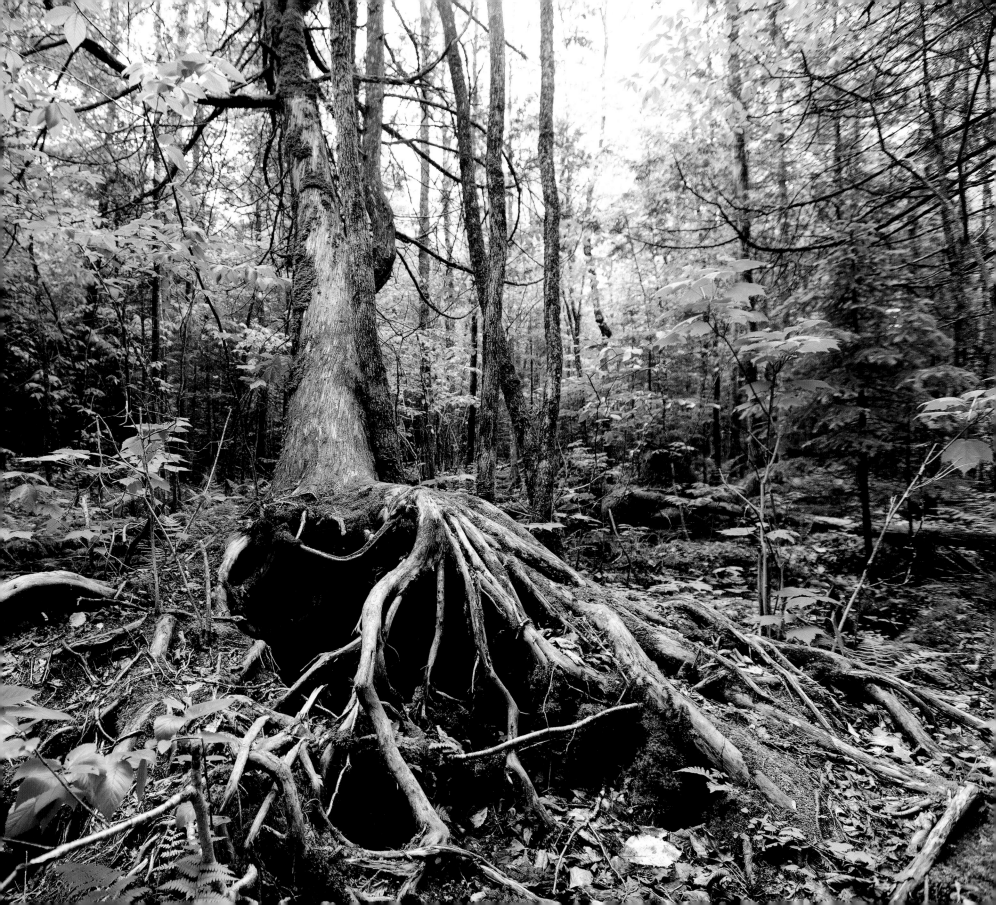

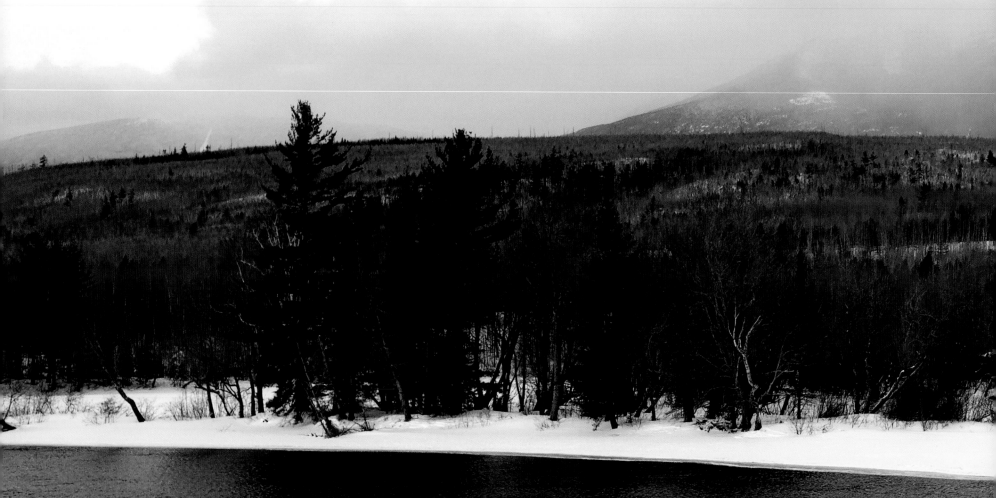

Sometimes it seemed as if the summit would be cleared in a few moments, and smile in sunshine: but what was gained on one side was lost on another. It was like sitting in a chimney and waiting for the smoke to blow away. It was, in fact, a cloud-factory, —these were the cloud-works, and the wind turned them off done from the cool, bare rocks.

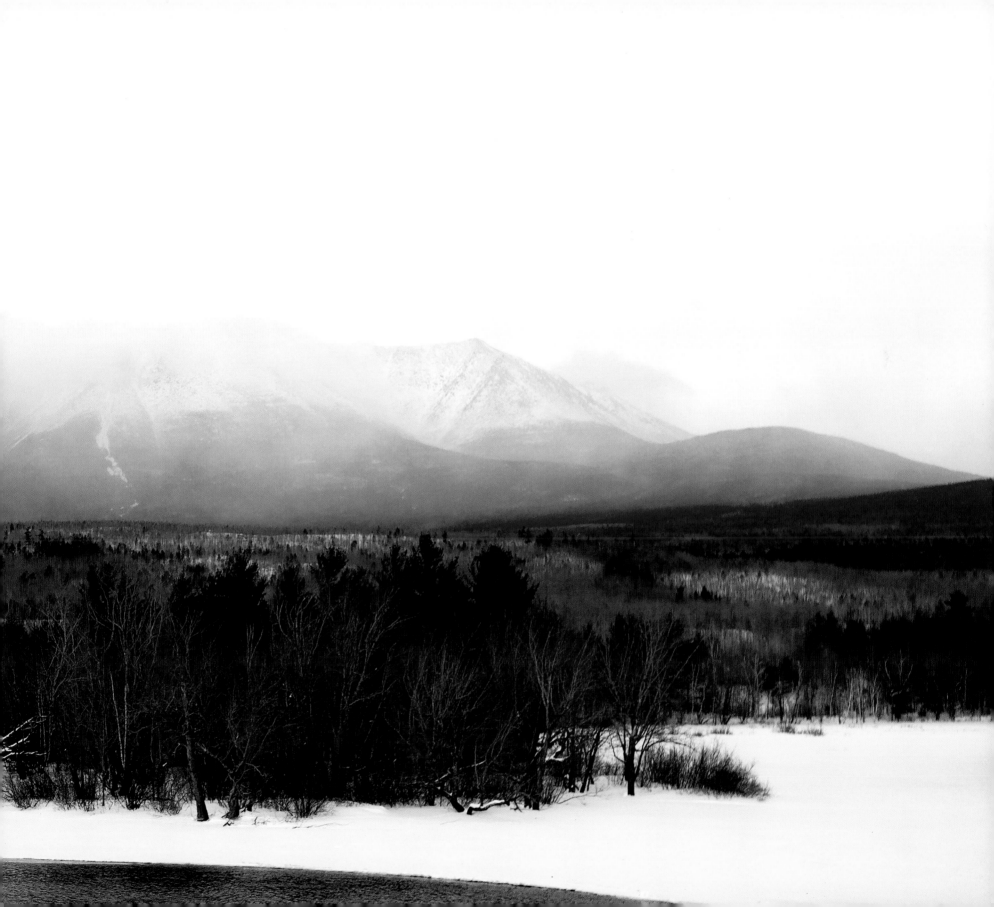

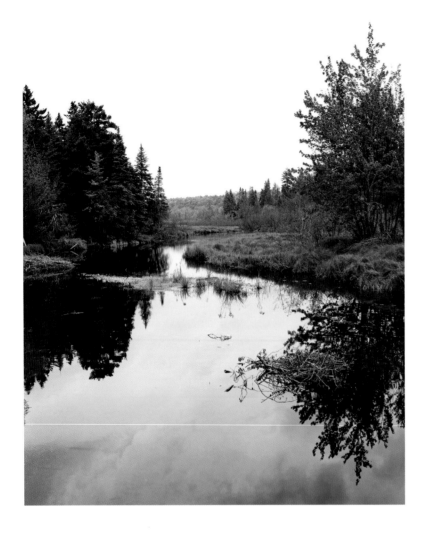

The utmost familiarity with dead streams, or with the ocean, would not prepare a man for this peculiar navigation; and the most skillful boatman anywhere else would here be obliged to take out his boat and carry round a hundred times, still with great risk, as well as delay, where the practised batteau-man poles up with comparative ease and safety. The hardy "voyageur" pushes with incredible perseverance and success quite up to the foot of the falls, and then only carries round some perpendicular ledge, and launches again in "The torrent's smoothness, ere it dash below," to struggle with the boiling rapids above.

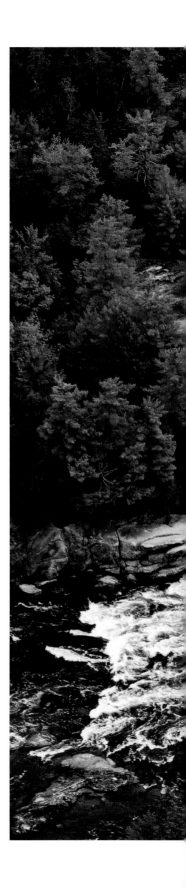

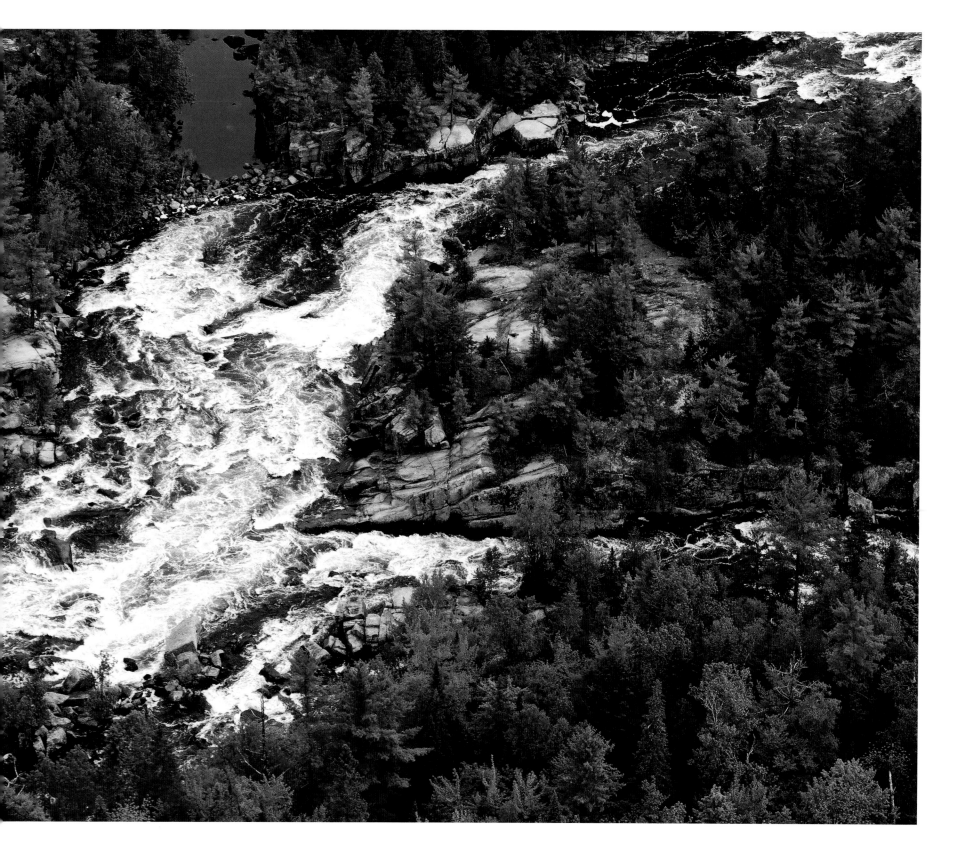

At a fork in the road
between Abbot and Monson, about
twenty miles from Moosehead Lake,
I saw a guide-post surmounted by
a pair of moose-horns, spreading
four or five feet, with the word
"Monson" painted on one blade, and
the name of some other town on the
other. They are sometimes used for
ornamental hat-trees, together with
deers' horns, in front entries; but,
after the experience which I shall
relate, I trust that I shall have a better
excuse for killing a moose than that I
may hang my hat on his horns.

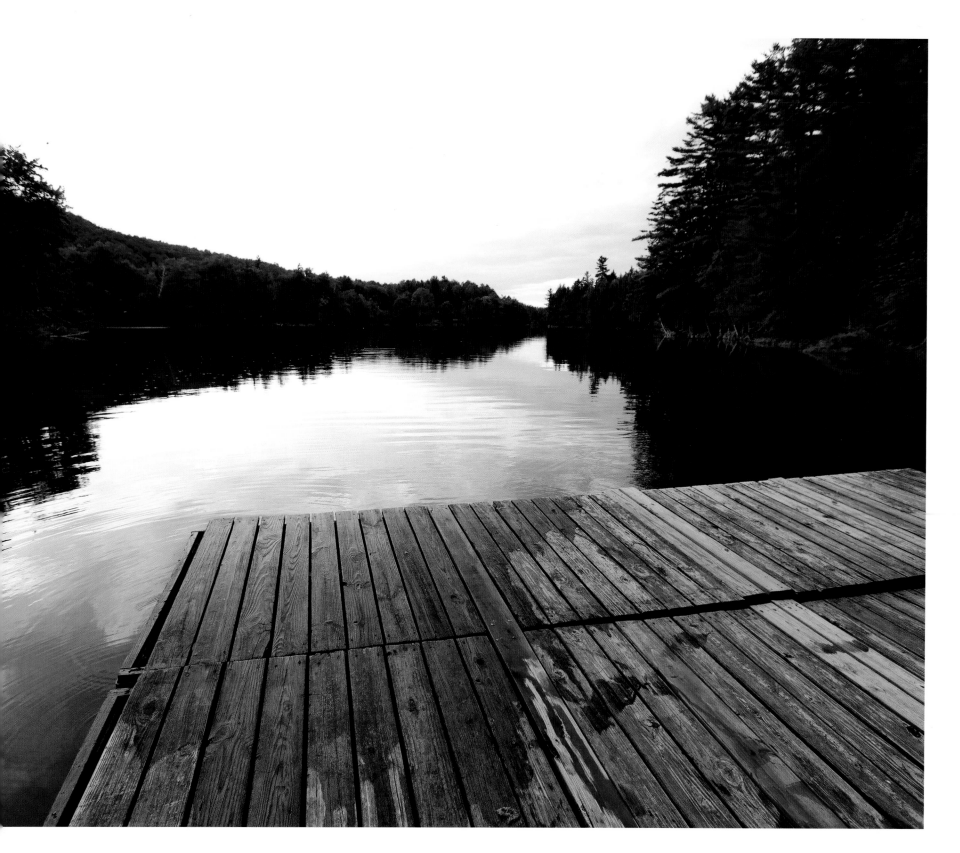

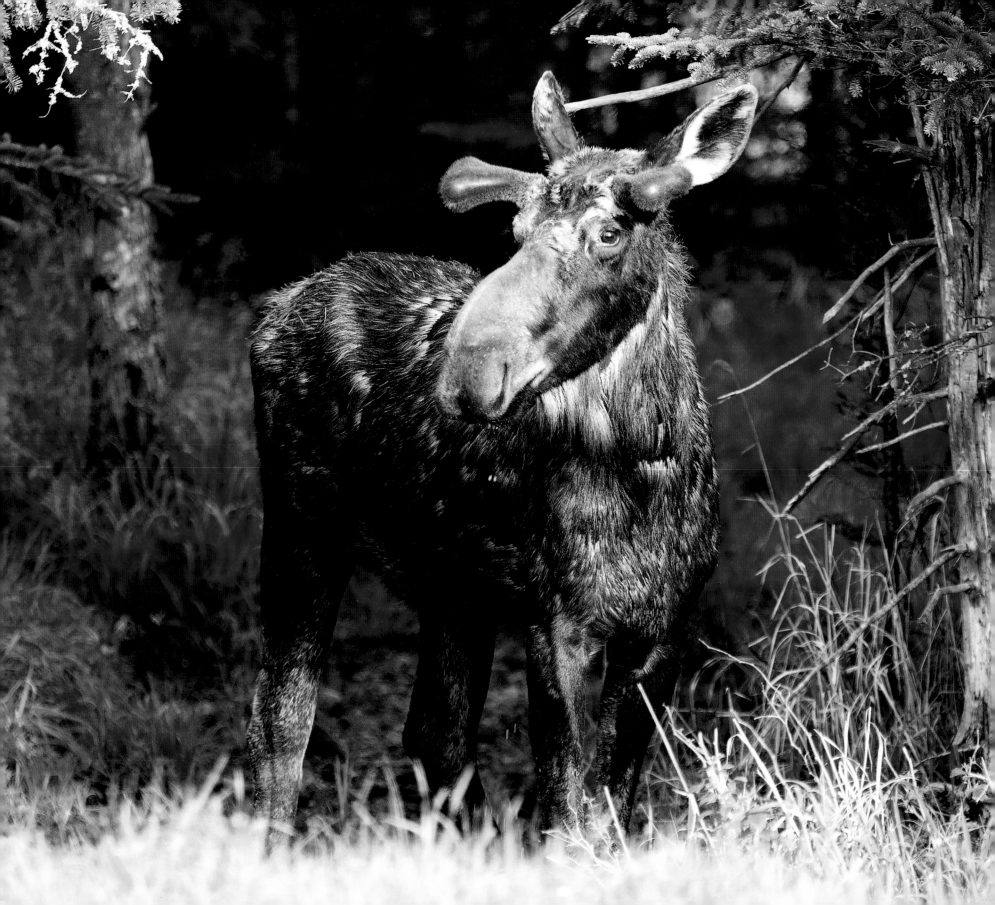

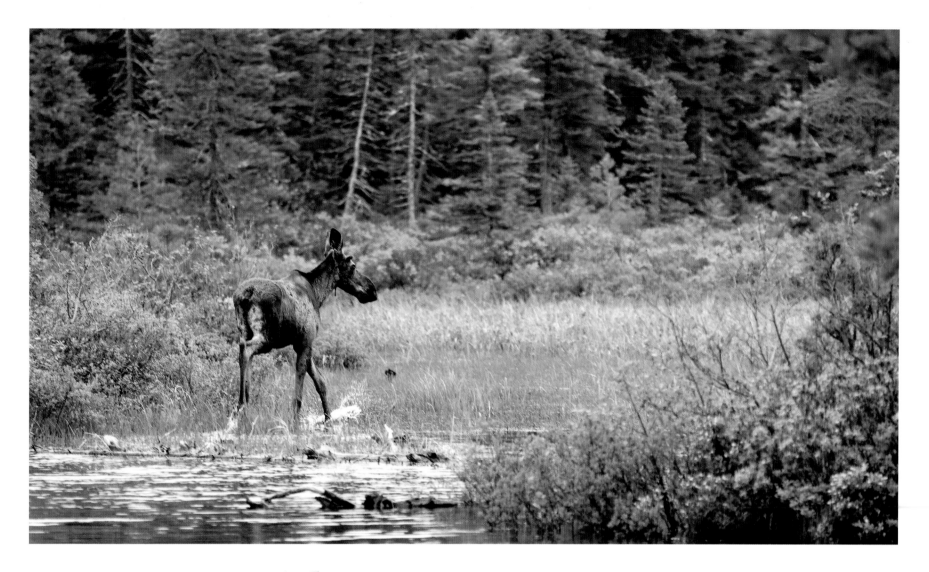

The moose is singularly grotesque and awkward to look at. Why should it stand so high at the shoulders? Why have so long a head? Why have no tail to speak of? For in my examination I overlooked it entirely. Naturalists say it is an inch and a half long. It reminded me at once of the camelopard, high before and low behind, —and no wonder, for, like it, it is fitted to browse on trees. The upper lip projected two inches beyond the lower for this purpose. This was the kind of man that was at home there; for, as near as I can learn, that has never been the residence, but rather the hunting-ground of the Indian. The moose will perhaps one day become extinct; but how naturally then, when it exists only as a fossil relic, and unseen as that, may the poet or sculptor invent a fabulous animal with similar branching and leafy horns, —a sort of fucus or lichen in bone, —to be the inhabitant of such a forest as this!

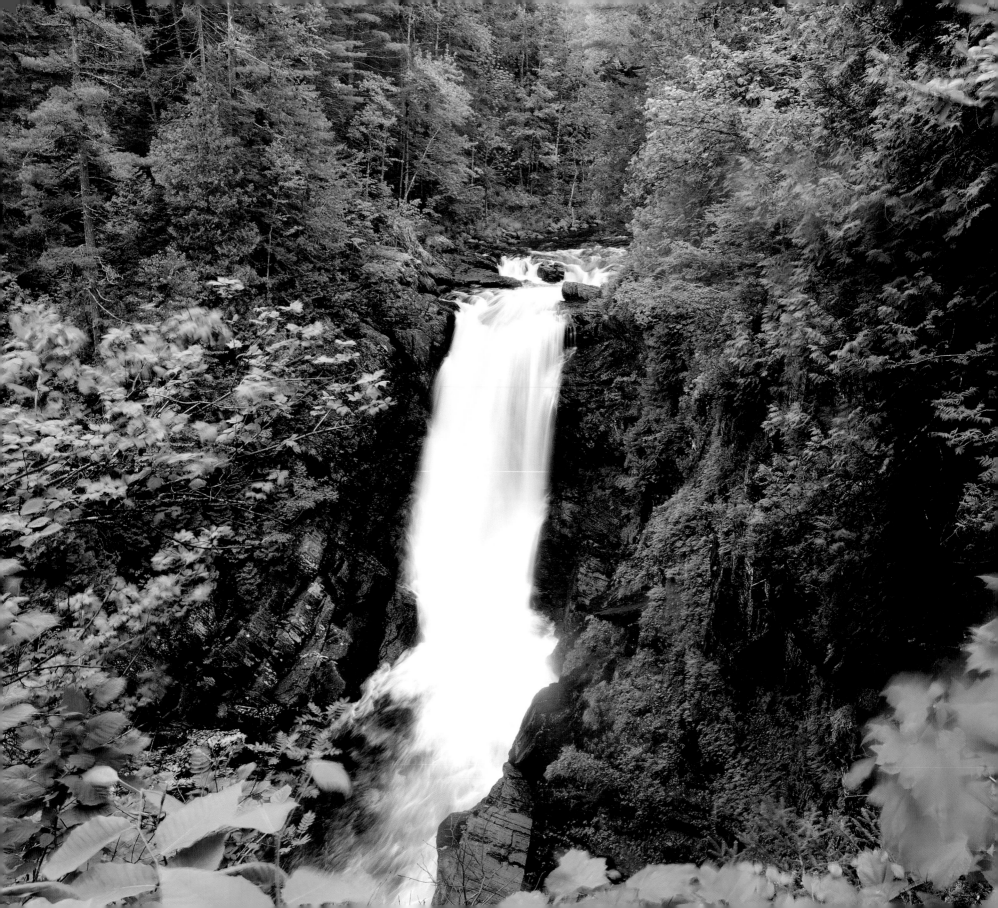

We had heard of a Grand Fall on this stream, and thought that each fall we came to must be it, but after christening several in succession with this name, we gave up the search. There were more Grand or Pretty Falls than I can remember.

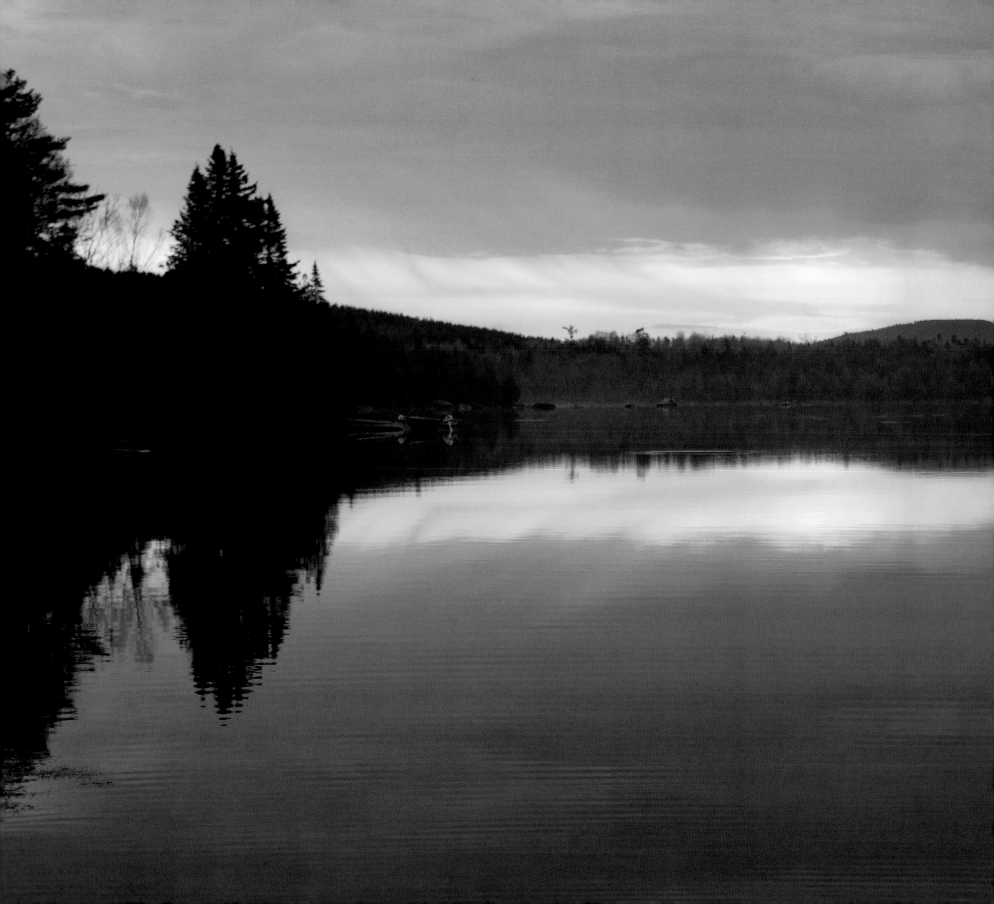

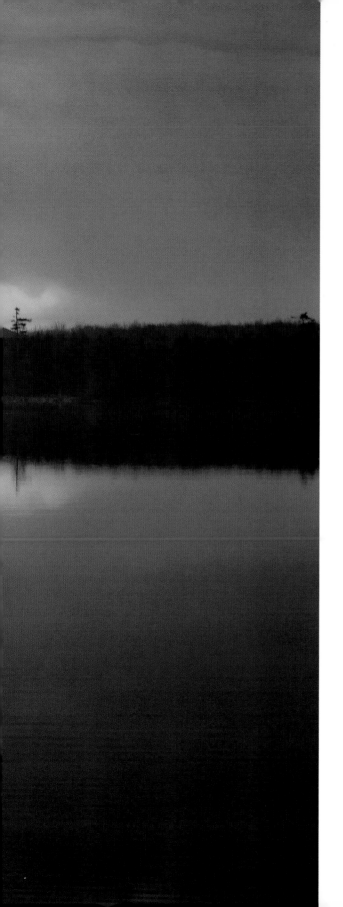

You commonly make your camp just at sundown, and are collecting wood, getting your supper, or pitching your tent while the shades of night are gathering around and adding to the already dense gloom of the forest. You have no time to explore or look around you before it is dark. You may penetrate half a dozen rods farther into that twilight wilderness, after some dry bark to kindle your fire with, and wonder what mysteries lie hidden still deeper in it . . . or you may run down to the shore for a dipper of water But there is no sauntering off to see the country, and ten or fifteen rods seems a great way from your companions, and you come back with the air of a much travelled man, as from a long journey, with adventures to relate and at a hundred rods you might be lost past recovery, and have to camp out. It is all mossy and moosey. In some of those dense fir and spruce woods there is hardly room for the smoke to go up. The trees are a standing night, and every fir and spruce that you fell is a plume plucked from night's raven wing.

The shore was about one fourth of a mile distant, through a dense, dark forest, and as he led us back to it, winding rapidly about to the right and left, I had the curiosity to look down carefully, and found that he was following his steps backward. I could only occasionally perceive his trail in the moss, and yet he did not appear to look down nor hesitate an instant, but led us out exactly to his canoe. This surprised me, for without a compass, or the sight or noise of the river to guide us, we could not have kept our course many minutes, and could have retraced our steps but a short distance, with a great deal of pains and very slowly, using a laborious circumspection. But it was evident that he could go back through the forest wherever he had been during the day.

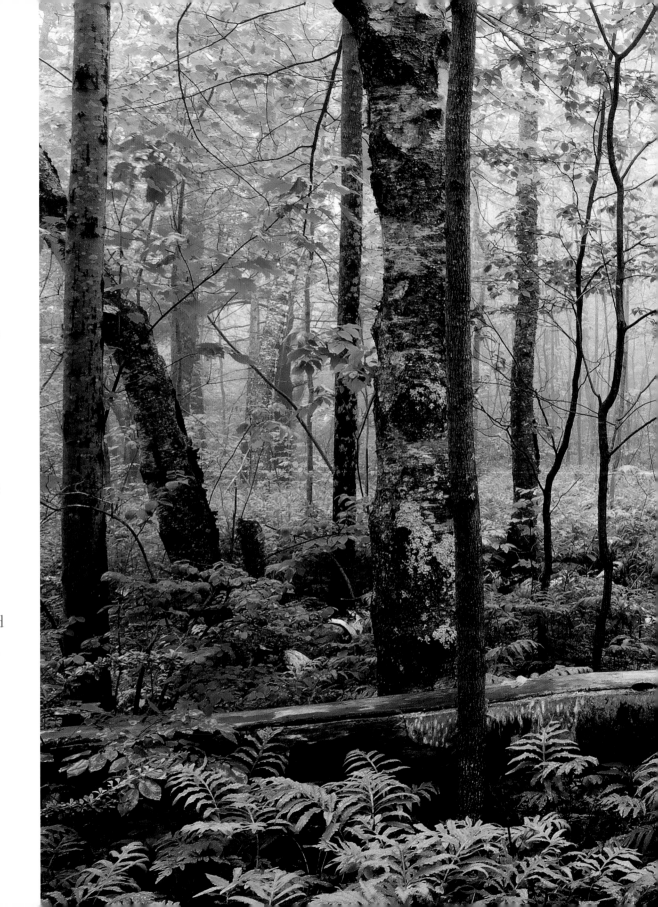

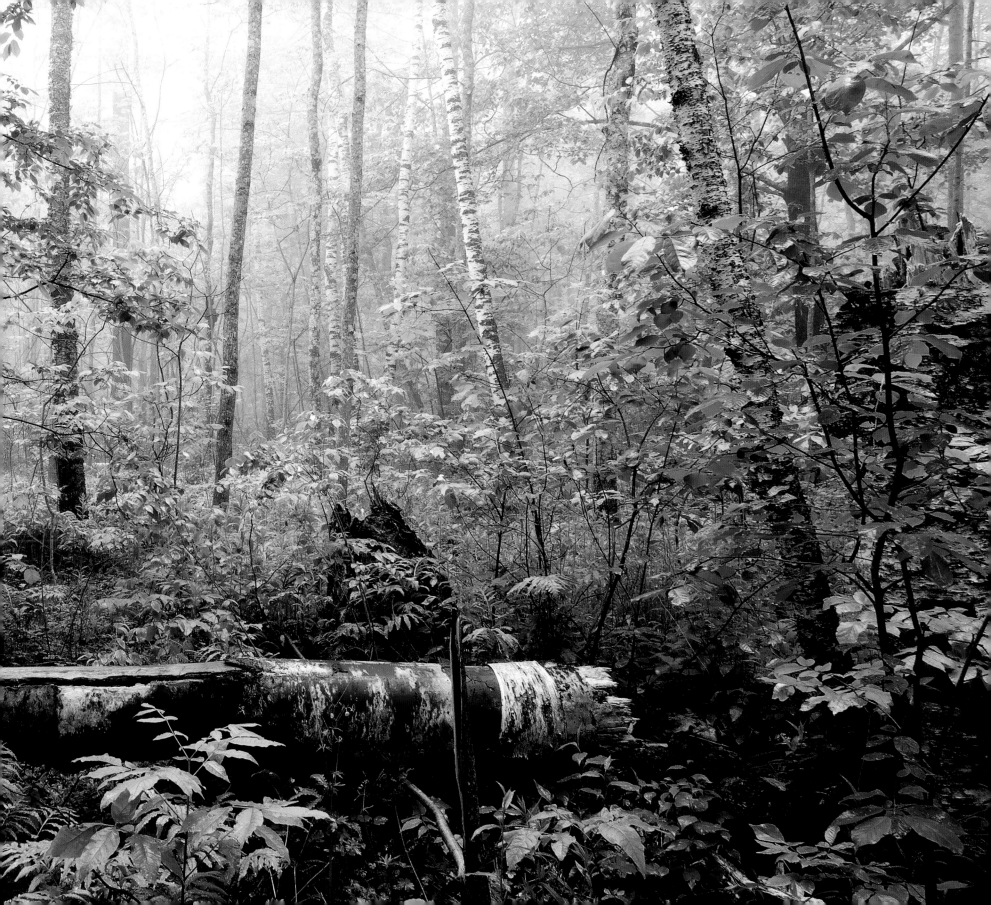

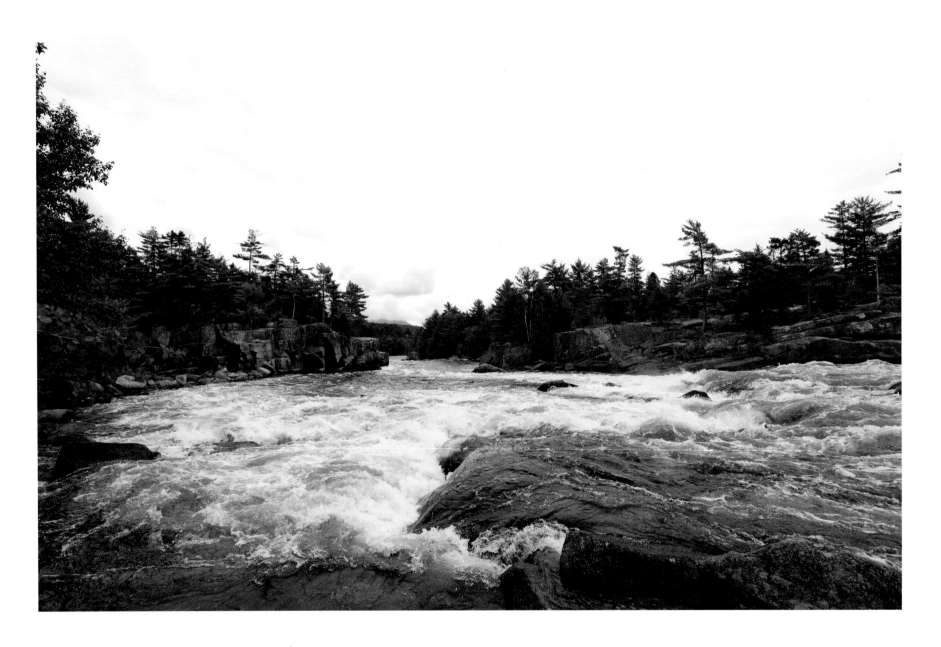

I remember once dreaming of pushing a canoe up the rivers of Maine, and that, when I had got so high that the channels were dry, I kept on through the ravines and gorges, nearly as well as before, by pushing a little harder, and now it seemed to me that my dream was partially realized.

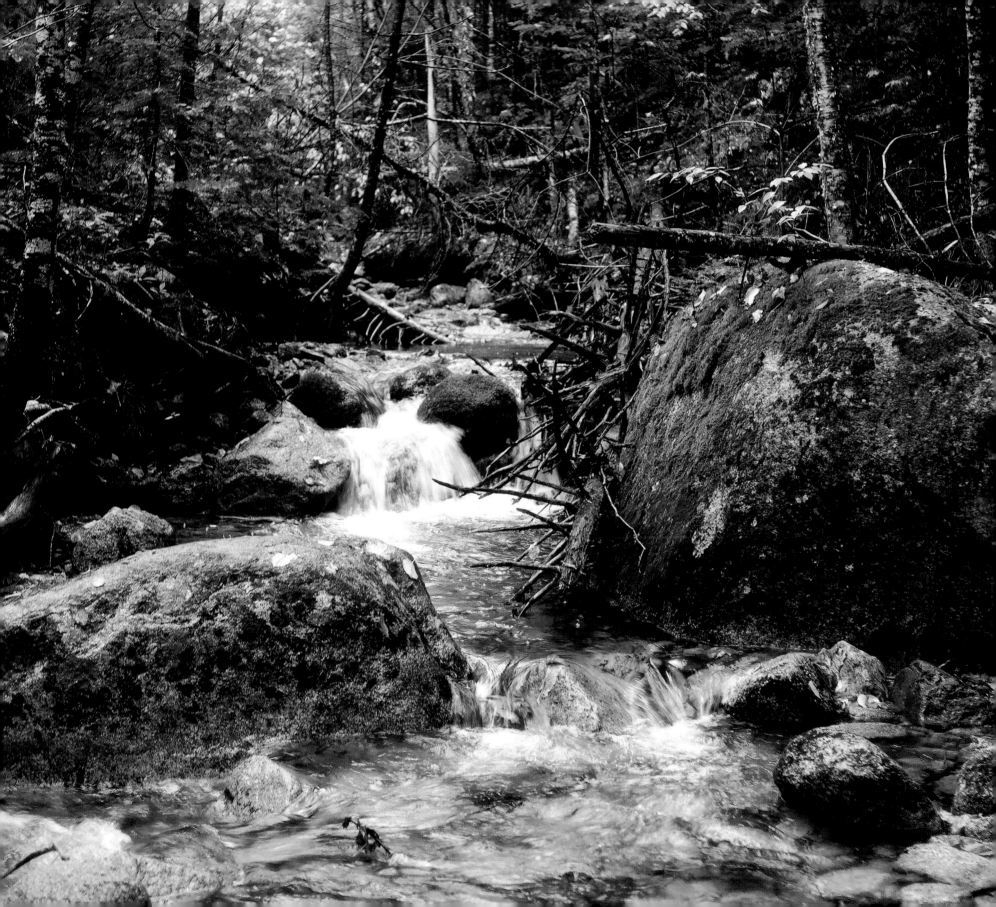

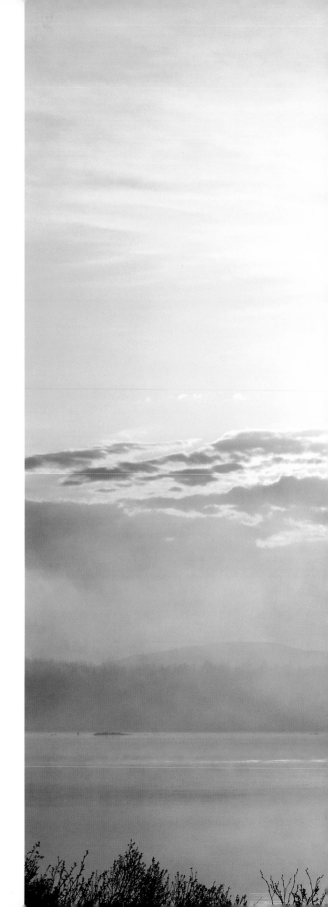

Each time that we lay on the shore of a lake,

we heard the voice of the loon, loud and distinct,

from far over the lake. It is a very wild sound, quite in

keeping with the place and the circumstances of the

traveller, and very unlike the voice of a bird. I could lie

awake for hours listening to it, it is so thrilling.

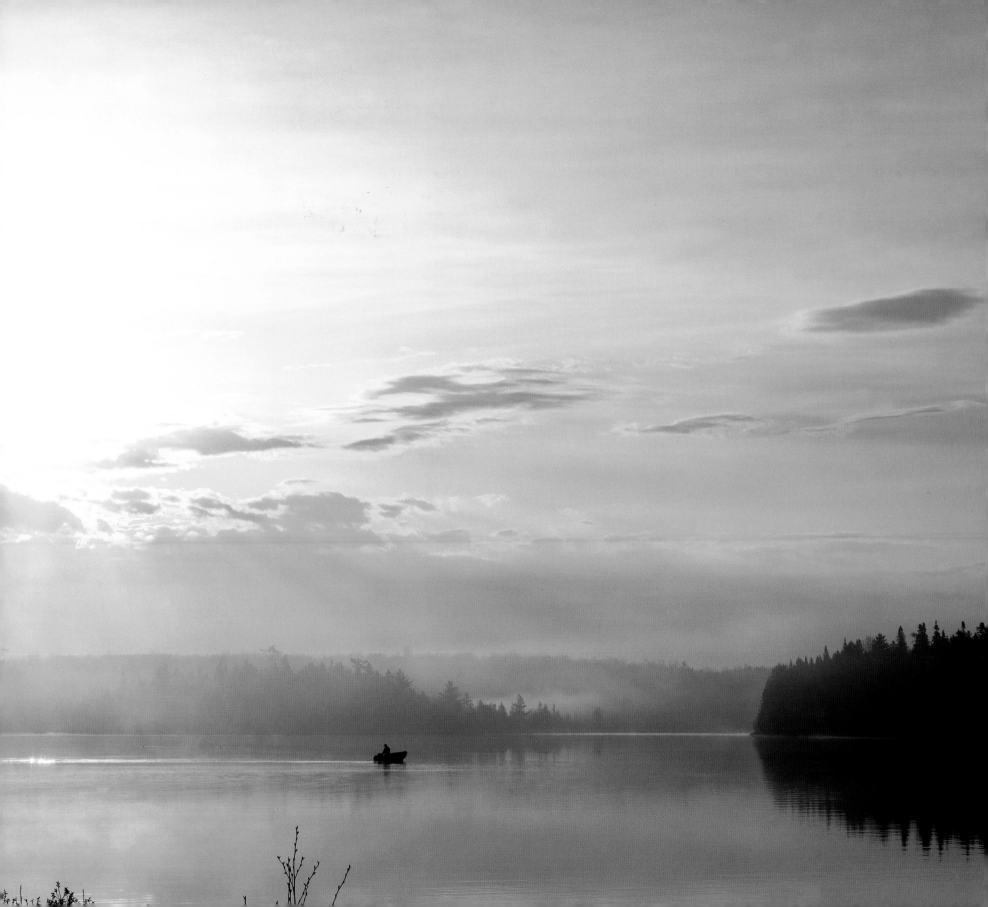

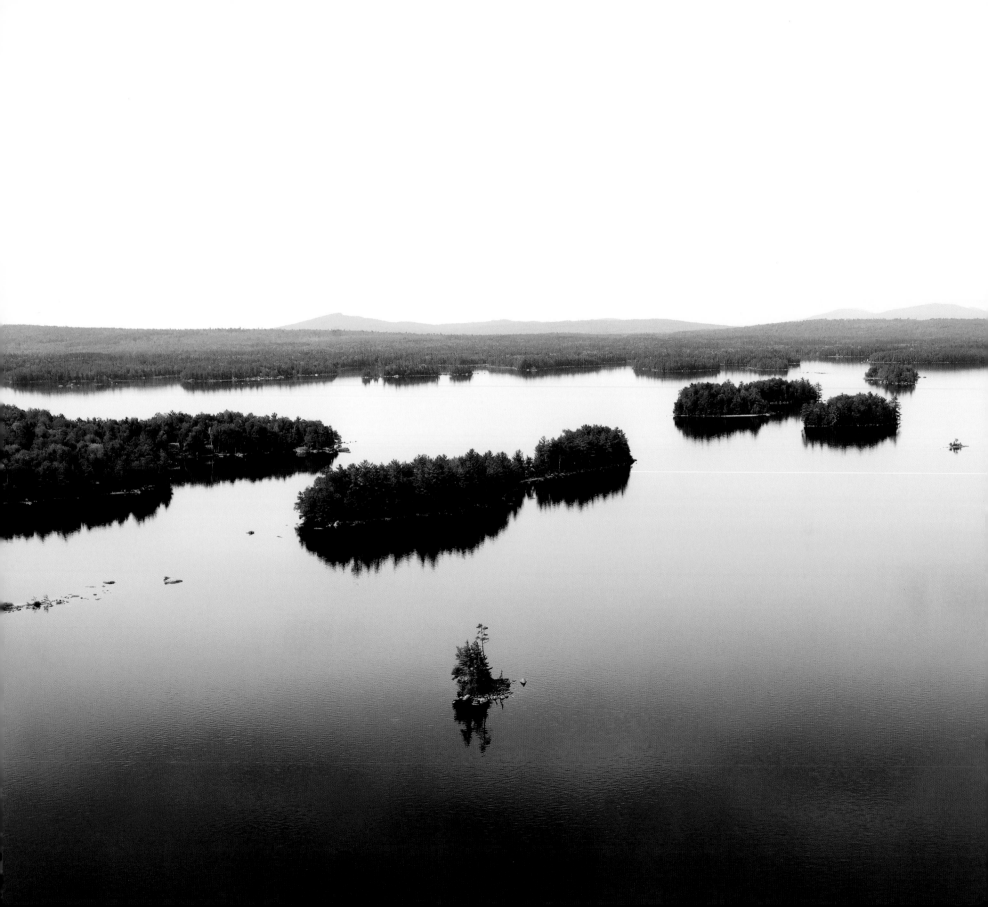

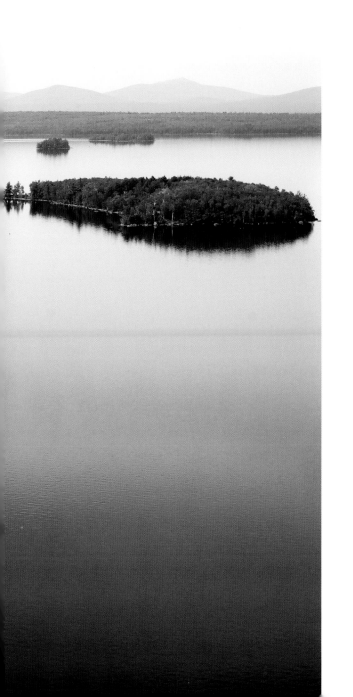

It is wonderful how well watered this country is. As you paddle across a lake, bays will be pointed out to you, by following up which, and perhaps the tributary stream which empties in, you may, after a short portage, or possibly, at some seasons, none at all, get into another river, which empties far away from the one you are on. Generally, you may go in any direction in a canoe, by making frequent but not very long portages. You are only realizing once more what all nature distinctly remembers here, for no doubt the waters flowed thus in a former geological period, and instead of being a lake country, it was an archipelago.

It is an agreeable change to cross a lake, after you have been shut up in the woods, not only on account of the greater expanse of water, but also of sky. It is one of the surprises which Nature has in store for the traveller in the forest. To look down, in this case, over eighteen miles of water, was liberating and civilizing even. No doubt, the short distance to which you can see in the woods, and the general twilight, would at length react on the inhabitants, and make them savages. The lakes also reveal the mountains, and give ample scope and range to our thought.

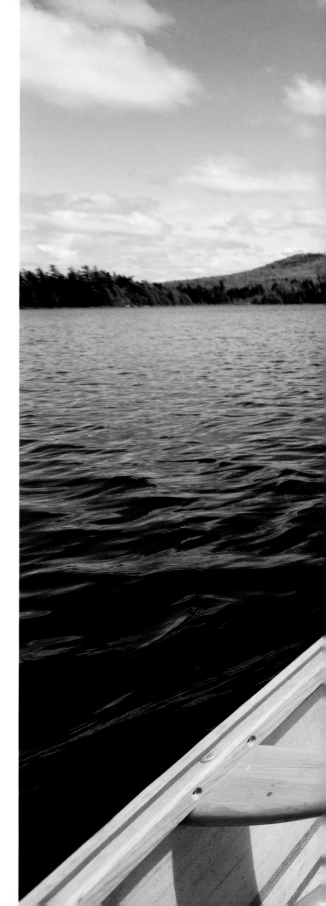

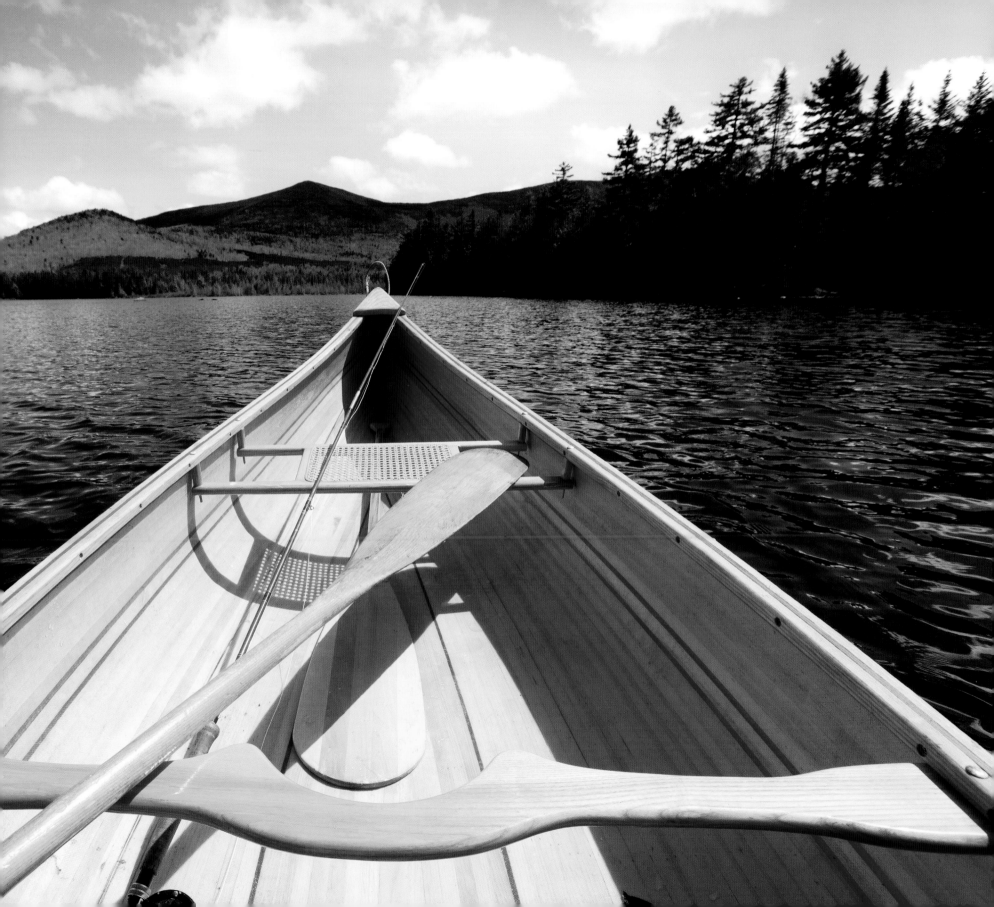

Wild as it was, it was hard for me to get rid of the associations of the settlements. Any steady and monotonous sound, to which I did not distinctly attend, passed for a sound of human industry. The waterfalls which I heard were not without their dams and mills to my imagination, —and several times I found that I had been regarding the steady rushing sound of the wind from over the woods beyond the rivers as that of a train of cars, —the cars at Quebec. Our minds anywhere, when left to themselves, are always thus busily drawing conclusions from false premises.

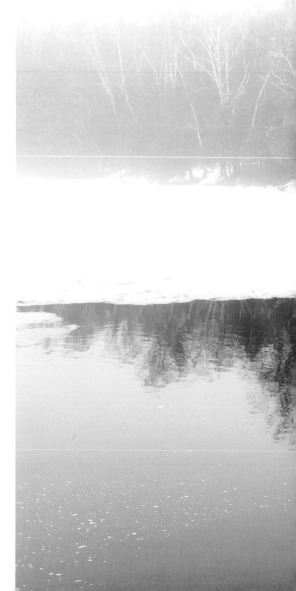

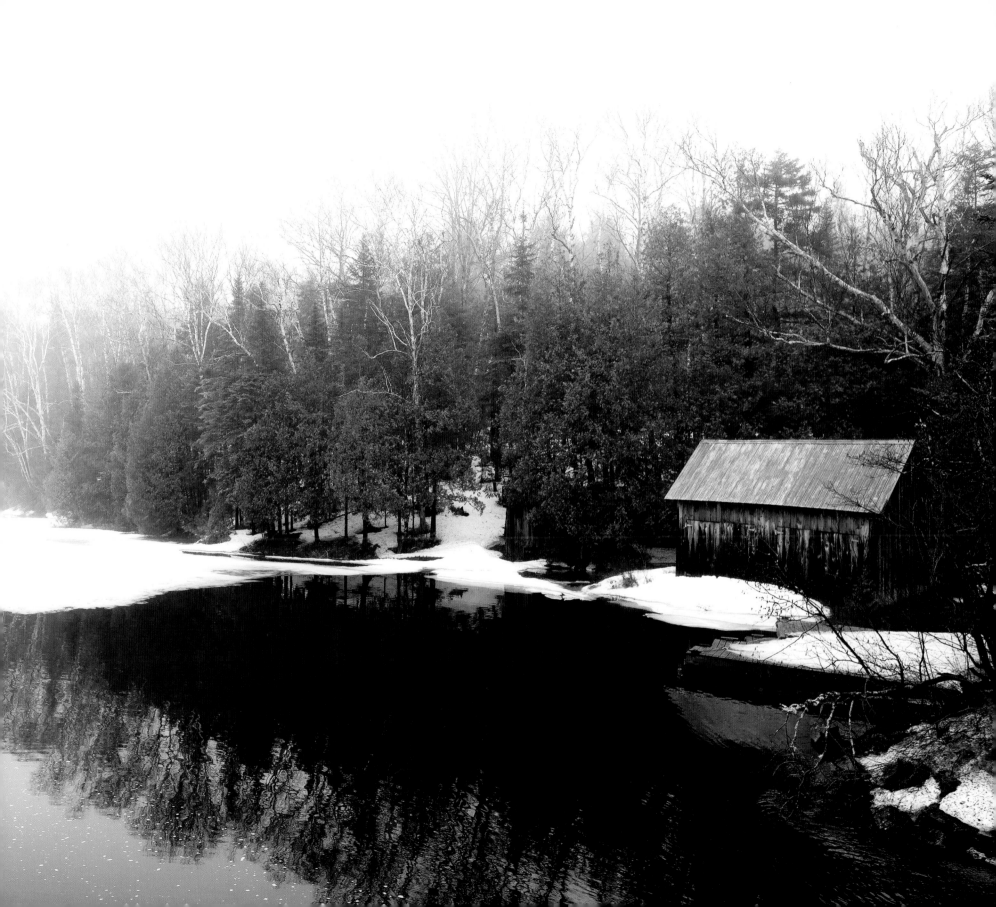

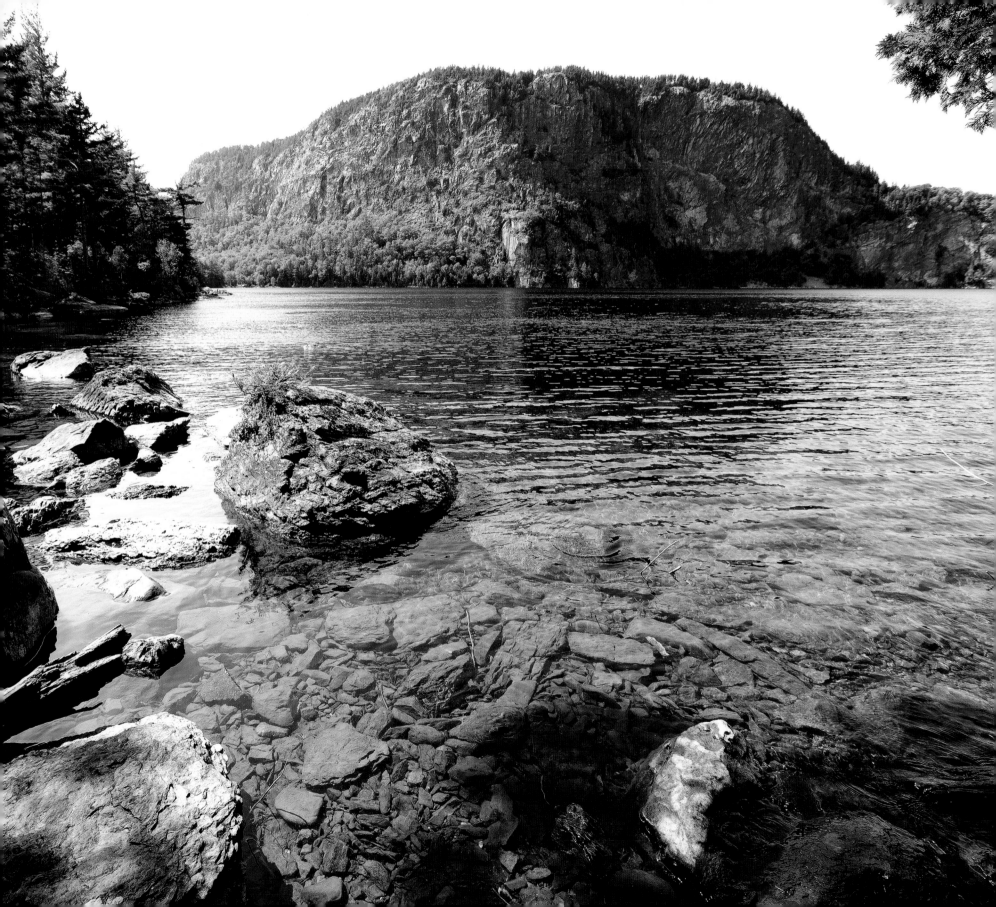

While we were crossing this bay, where Mount Kineo rose dark before us, within two or three miles, the Indian repeated the tradition respecting this mountain's having anciently been a cow moose, —how a mighty Indian hunter, whose name I forget, succeeding in killing this queen of the moose tribe with great difficulty. . . . Jackson, in his Report on the Geology of Maine, in 1838, says of this mountain: "Hornstone, which will answer for flints, occurs in various parts of the State. . . . The largest mass of this stone known in the world is Mount Kineo, upon Moosehead Lake, which appears to be entirely composed of it, and rises seven hundred feet above the lake level. This variety of hornstone I have seen in every part of New England in the form of Indian arrowheads, hatchets, chisels, etc., which were probably obtained from this mountain by the aboriginal inhabitants of the country."

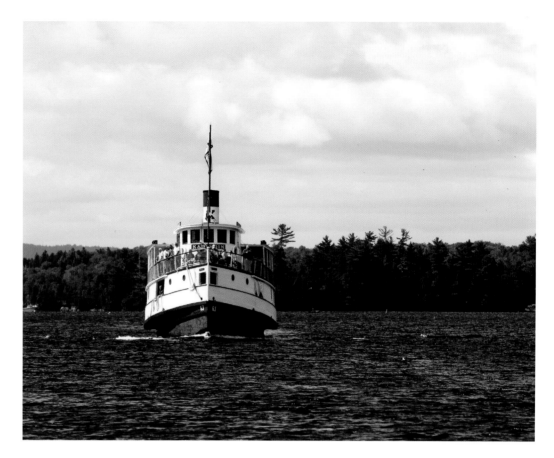

After passing Deer Island, we saw the little steamer from Greenville, far east in the middle of the lake, and she appeared nearly stationary. Sometimes we could hardly tell her from an island that had a few trees on it.

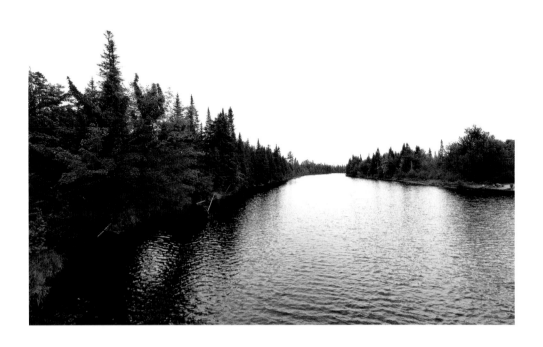

It was inspiriting to hear the regular dip of

the paddles, as if they were our fins or flippers,

and to realize that we were at length fairly

embarked. We who had felt strangely as stage-

passengers and tavern-lodgers were suddenly

naturalized there and presented with the

freedom of the lakes and the woods.

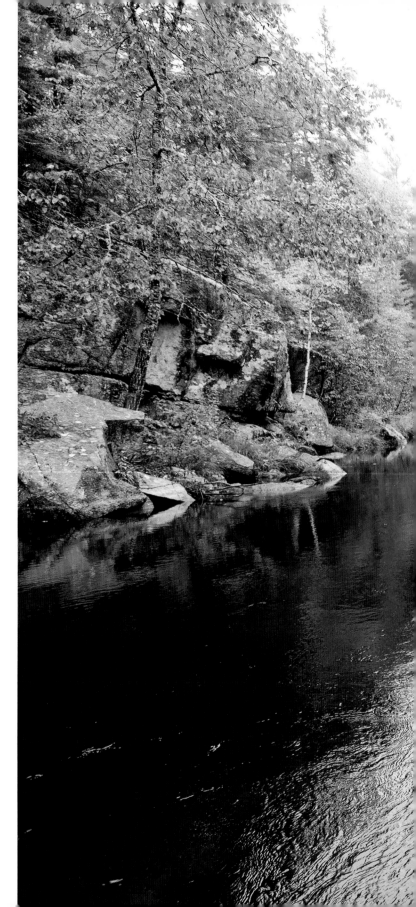

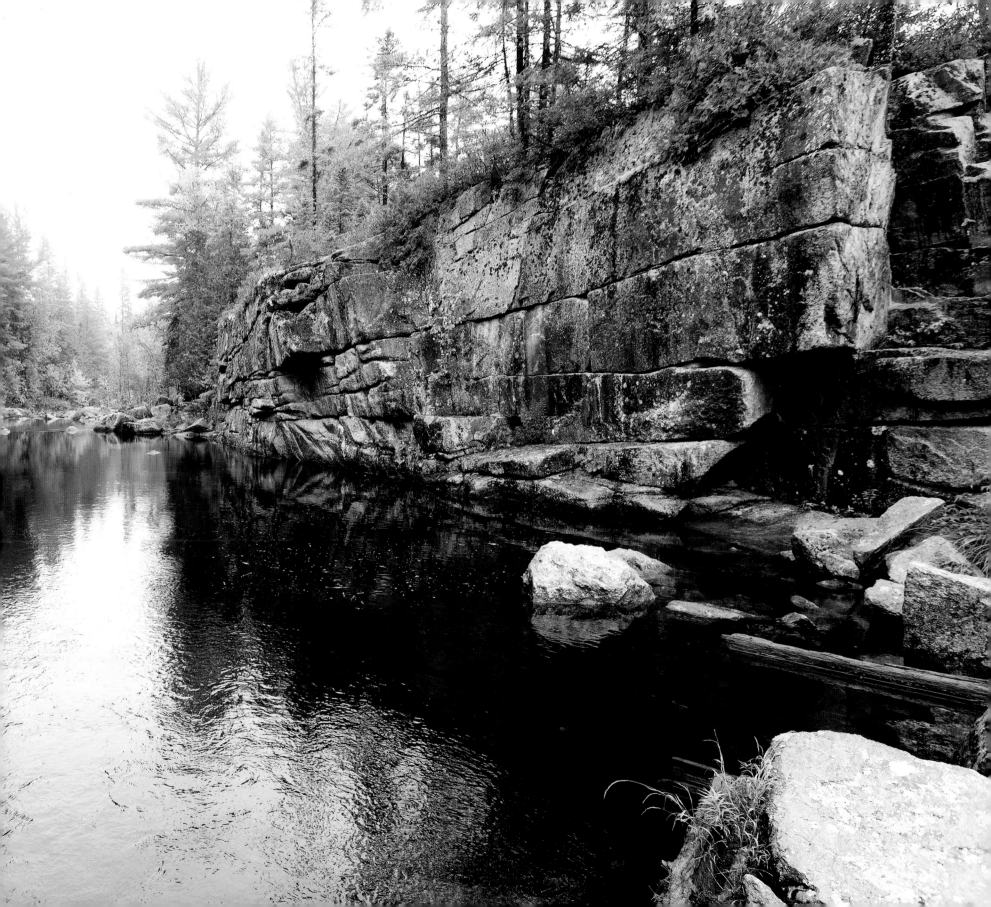

The kings of England formerly had their forests "to hold the king's game," for sport or food, sometimes destroying villages to create or extend them; and I think that they were impelled by a true instinct. Why should not we, who have renounced the king's authority, have our national preserves, where no villages need be destroyed, in which the bear and panther, and some even of the hunter race, may still exist, and not be "civilized off the face of the earth,"—our forests, not to hold the king's game merely, but to hold and preserve the king himself also, the lord of creation,—not for idle sport or food, but for inspiration and our own true re-creation? or shall we, like villains, grub them all up, poaching on our own national domains?

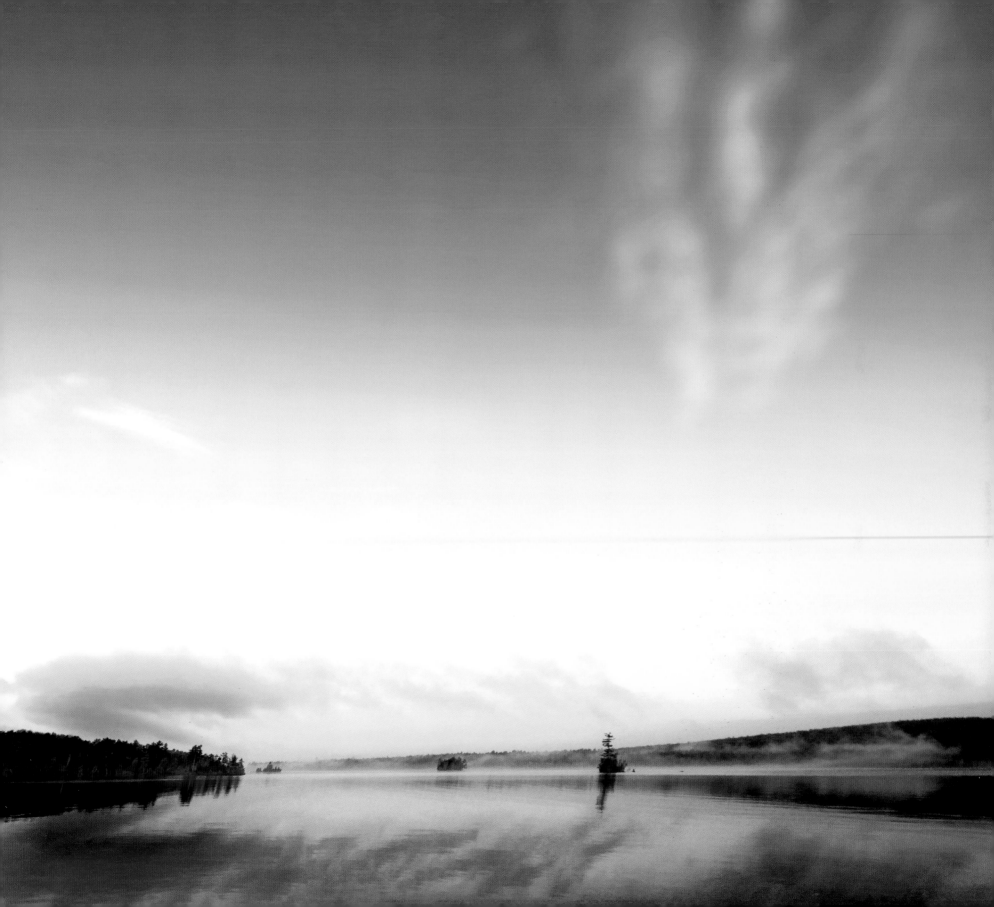

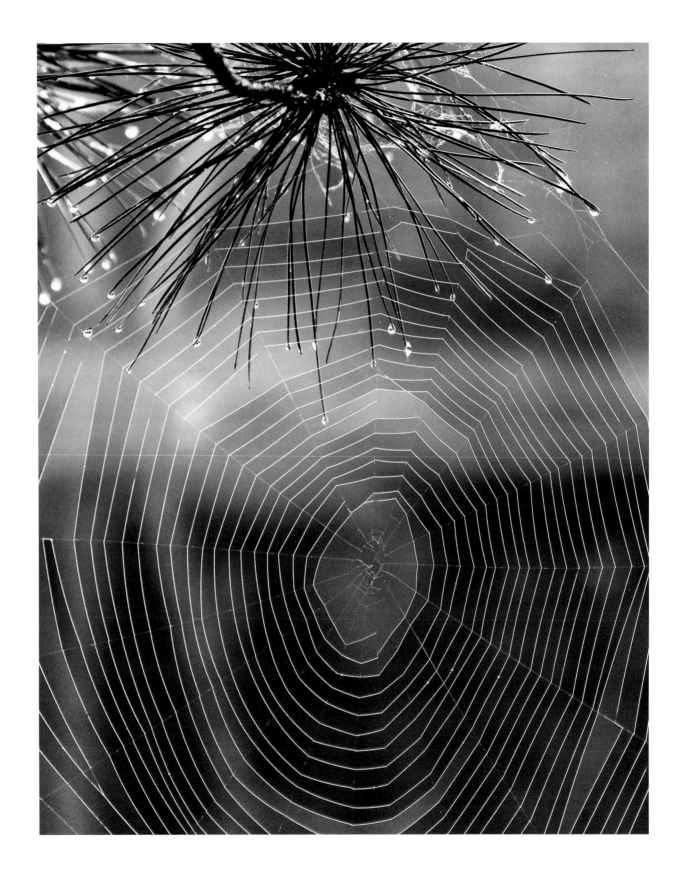

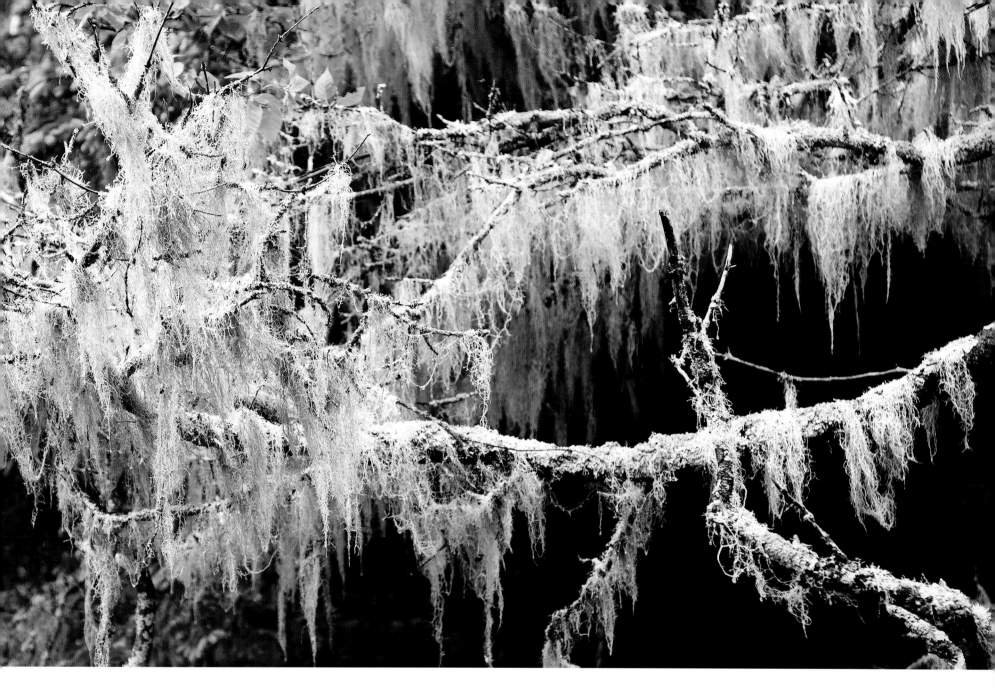

The civilized man not only clears the land permanently to a great extent, and cultivates open fields, but he tames and cultivates to a certain extent the forest itself. By his mere presence, almost, he changes the nature of the trees as no other creature does. The sun and air, and perhaps fire, have been introduced, and grain raised where it stands. It has lost its wild, damp, and shaggy look, the countless fallen and decaying trees are gone, and consequently that thick coat of moss which lived on them is gone too. The earth is comparatively bare and smooth and dry. The most primitive places left with us are the swamps, where the spruce still grows shaggy with usnea.

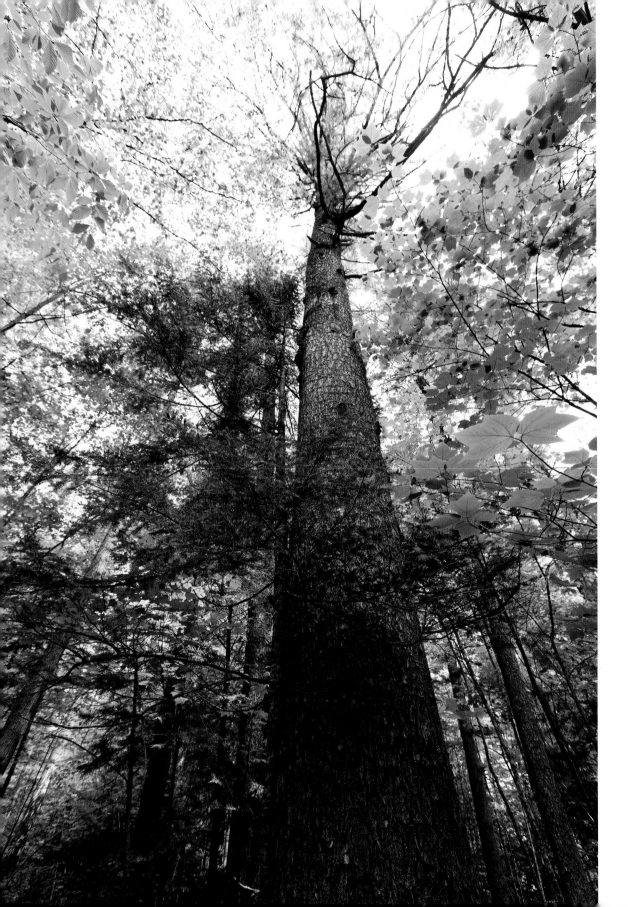

One connected with lumbering operations at Bangor told me that the largest pine belonging to his firm, cut the previous winter, "scaled" in the woods four thousand five hundred feet, and was worth ninety dollars in the log at the Bangor boom in Oldtown. They cut a road three and a half miles long for this tree alone.

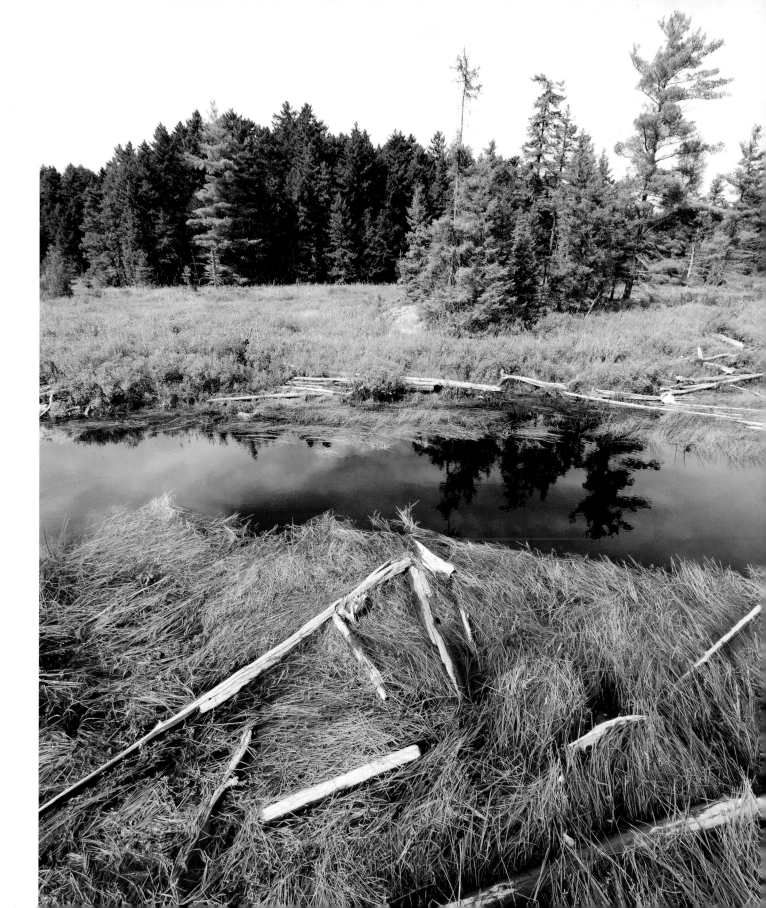

The Indian

said that the Umbazookskus, being a dead stream with broad meadows, was a good place for moose, and he frequently came a-hunting here, being out alone three weeks or more from Oldtown. He sometimes, also, went a-hunting to the Seboois Lakes, taking the stage, with his gun and ammunition, axe and blankets, hard bread and pork, perhaps for a hundred miles of the way, and jumped off at the wildest place on the road, where he was at once at home, and every rod was a tavern-site for him.

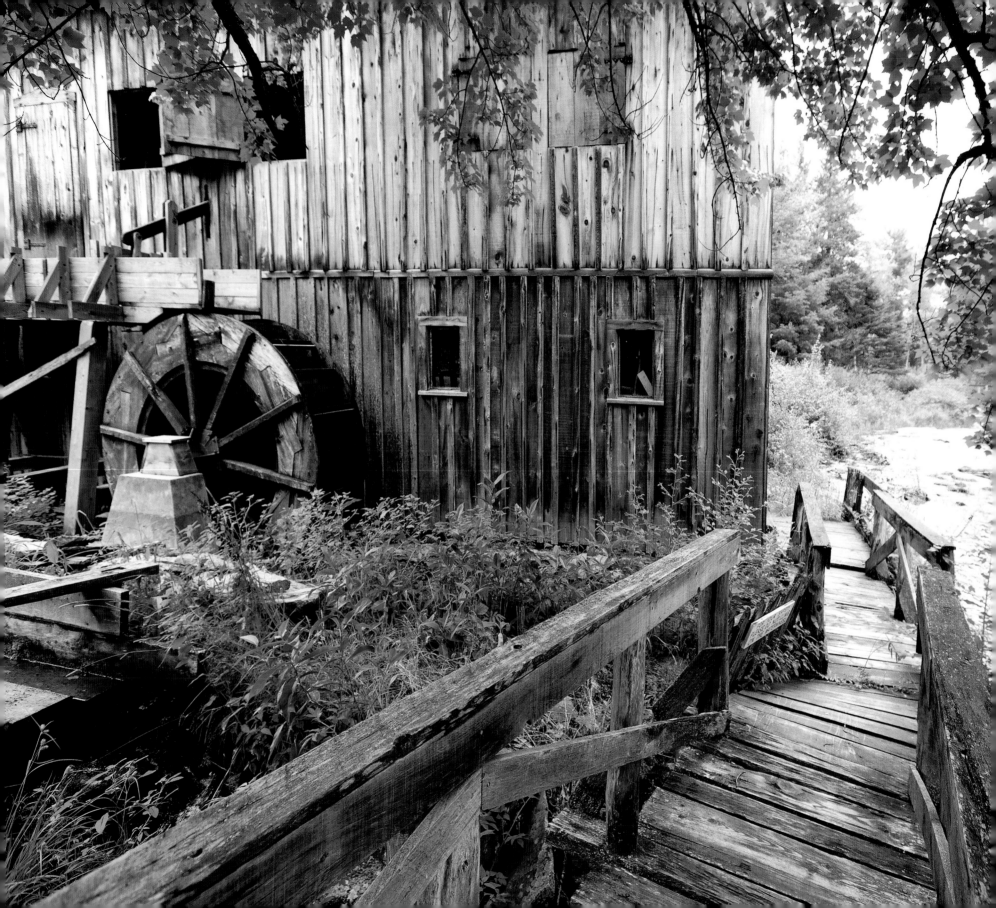

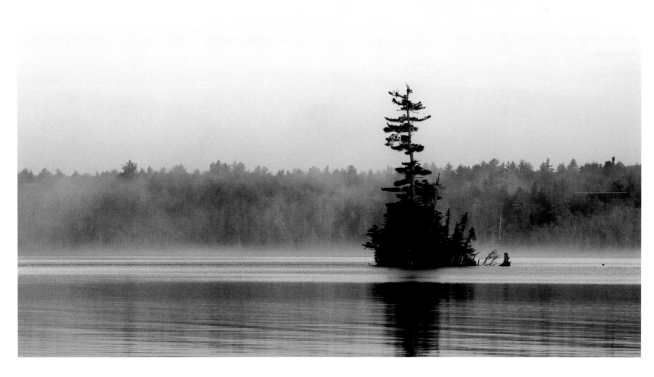

At last we glided past the "green isle," which had been our landmark, all joining in the chorus; as if by the watery links of rivers and of lakes we were about to float over unmeasured zones of earth, bound on unimaginable adventures.

At the end of three miles, we came to the Mattaseunk stream and mill, where there was even a rude wooden railroad running down to the Penobscot, the last railroad we were to see. We crossed one tract, on the bank of the river, of more than a hundred acres of heavy timber, which had just been felled and burnt over, and was still smoking. Our trail lay through the midst of it, and was well nigh blotted out.

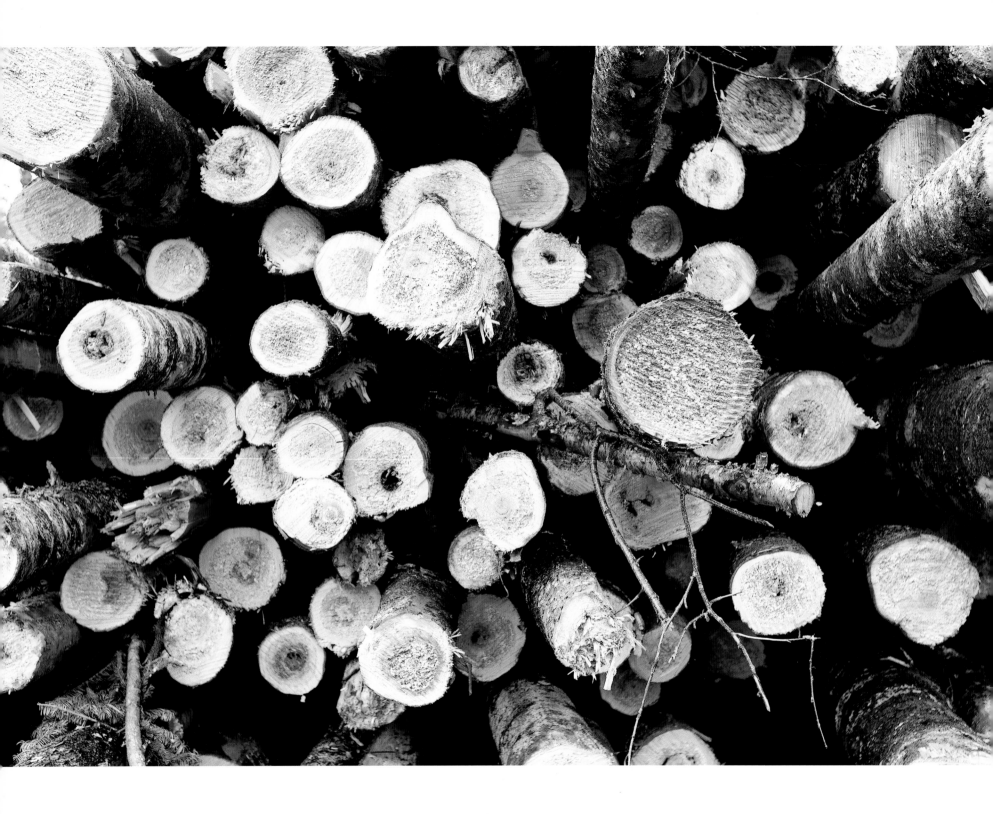

The mills are built directly over and across the river. Here is a close jam, a hard rub, at all seasons; and then the once green tree, long since white, I need not say as the driven snow, but as a driven log, becomes lumber merely. Here your inch, your two and your three inch stuff begin to be, and Mr. Sawyer marks off those spaces which decide the destiny of so many prostrate forests Think how stood the white-pine tree on the shore of Chesuncook, its branches soughing with the four winds, and every individual needle trembling in the sunlight,—think how it stands with it now,—sold, perchance, to the New England Friction-Match Company! . . . No wonder that we hear so often of vessels which are becalmed off our coast, being surrounded a week at a time by floating lumber from the Maine woods. The mission of men there seems to be, like so many busy demons, to drive the forest all out of the country.

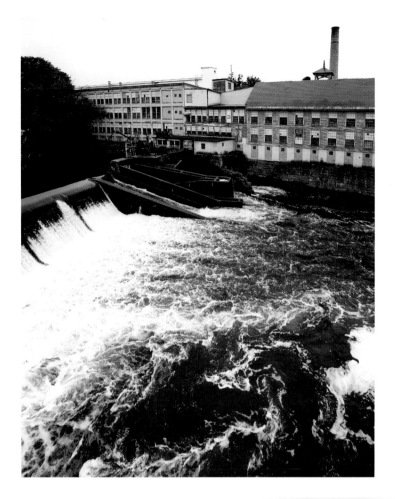

After a slight ascent from the lake through the springy soil of the Canadian's clearing, we entered on a level and very wet and rocky path through the universal dense evergreen forest, a loosely paved gutter merely, where we went leaping from rock to rock and from side to side, in the vain attempt to keep out of the water and mud. We concluded that it was yet Penobscot water, though there was no flow to it.

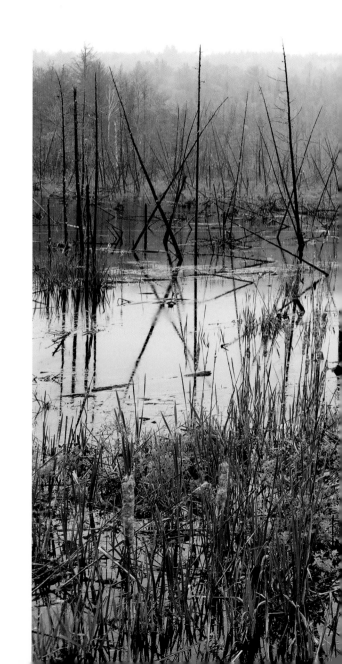

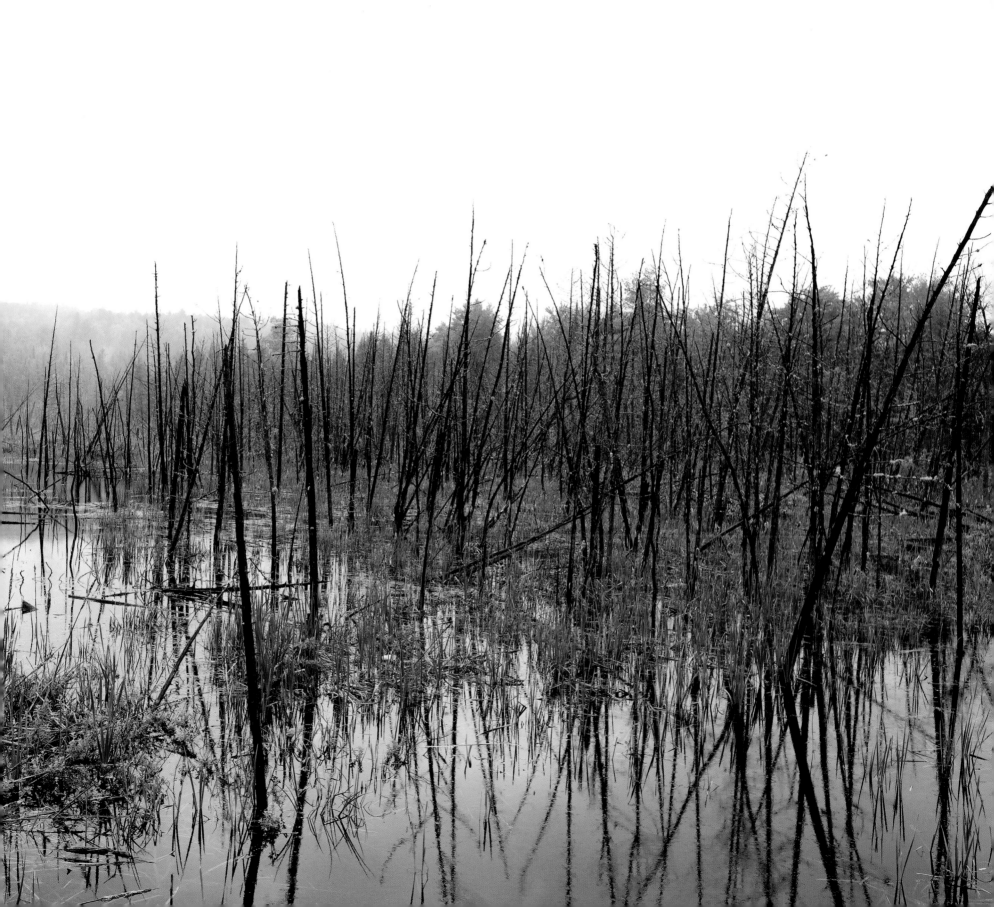

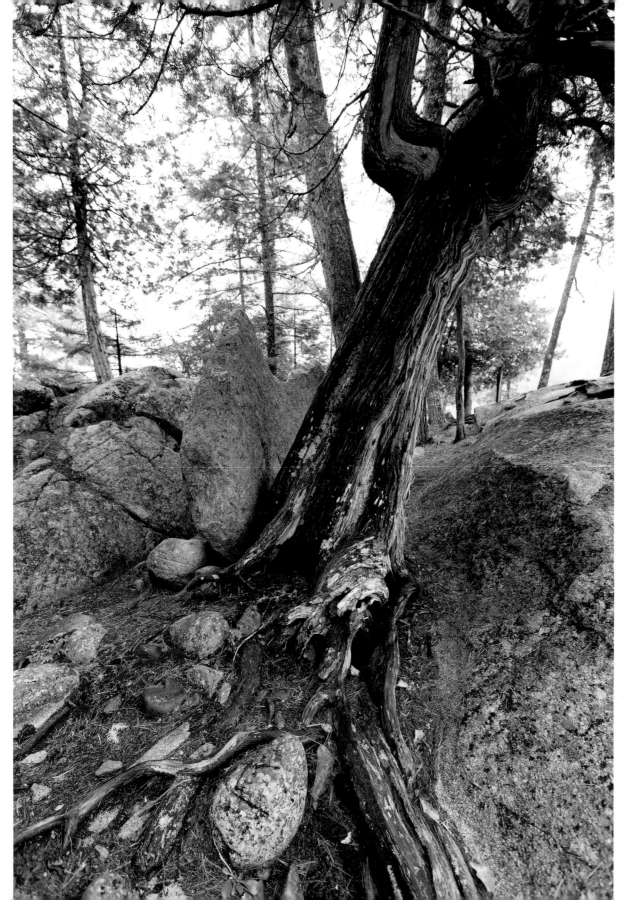

I have been into the lumber-yard, and the carpenter's shop, and the tannery, and the lampblack-factory, and the turpentine clearing; but when at length I saw the tops of the pines waving and reflecting the light at a distance high over all the rest of the forest, I realized that the former were not the highest use of the pine. It is not their bones or hide or tallow that I love most. It is the living spirit of the tree, not its spirit of turpentine, with which I sympathize, and which heals my cuts. It is as immortal as I am, and perchance will go to as high a heaven, there to tower above me still.

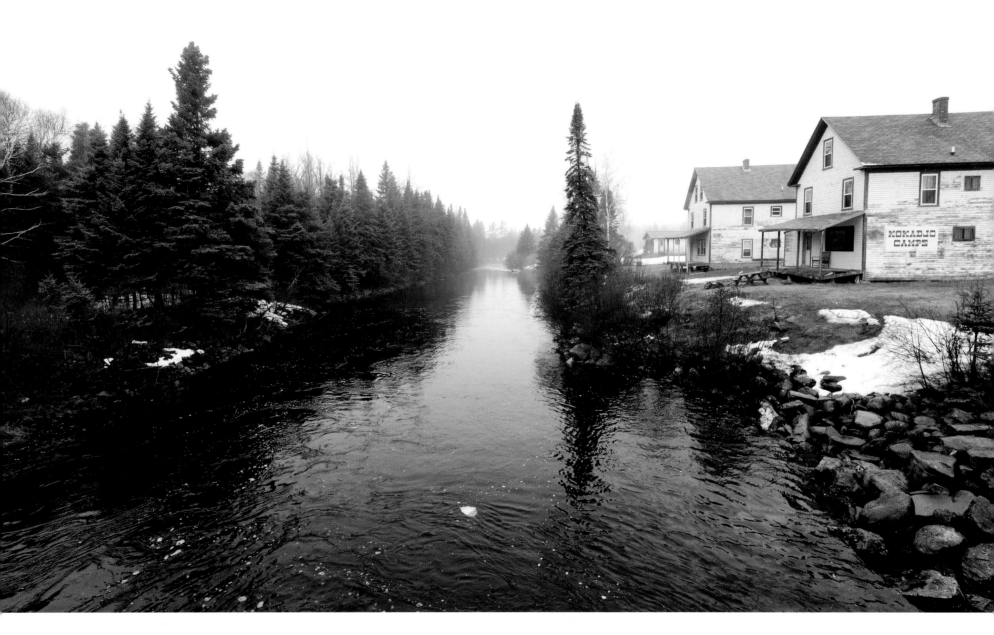

Such were the first rude beginnings of a town.

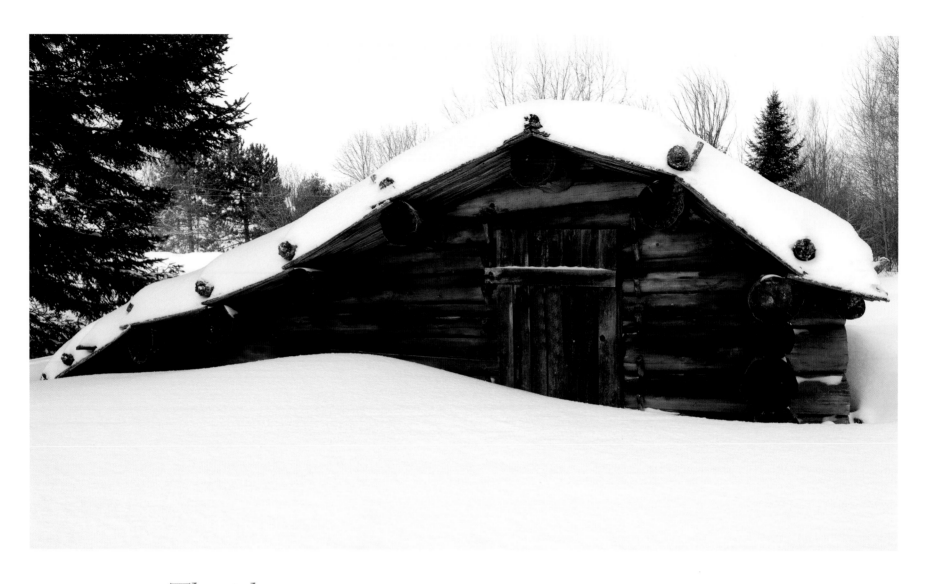

The sight of one of these frontier-houses, built of these great logs, whose inhabitants have unflinchingly maintained their ground many summers and winters in the wilderness, reminds me of famous forts, like Ticonderoga or Crown Point, which have sustained memorable sieges. They are especially winter-quarters, and at this season this one had a partially deserted look, as if the siege were raised a little, the snow-banks being melted from before it, and its garrison accordingly reduced. I think of their daily food as rations,—it is called "supplies;" a Bible and a great-coat are munitions of war, and a single man seen about the premises is a sentinel on duty.

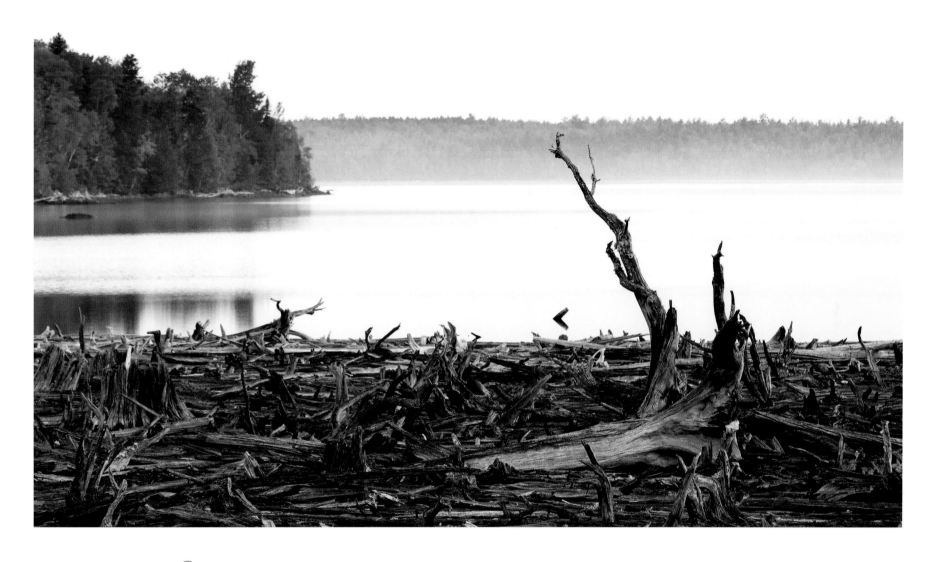

Some get their living exclusively by picking up the drift-wood and selling it by the cord in the winter. In one place I saw where an Irishman, who keeps a team and a man for the purpose, had covered the shore for a long distance with regular piles, and I was told that he had sold twelve hundred dollars' worth in a year. Another, who lived by the shore, told me that he got all the material of his out-buildings and fences from the river; and in that neighborhood I perceived that this refuse wood was frequently used instead of sand to fill hollows with, being apparently cheaper than dirt.

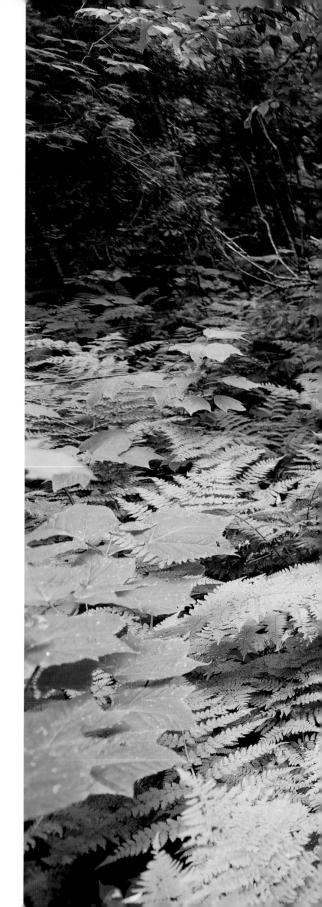

We sank a foot deep in water and mud at every step, and sometimes up to our knees, and the trail was almost obliterated We concluded that if Mud Pond was as muddy as the approach to it was wet, it certainly deserved its name. It would have been amusing to behold the dogged and deliberate pace at which we entered that swamp, without interchanging a word, as if determined to go through it, though it should come up to our necks.

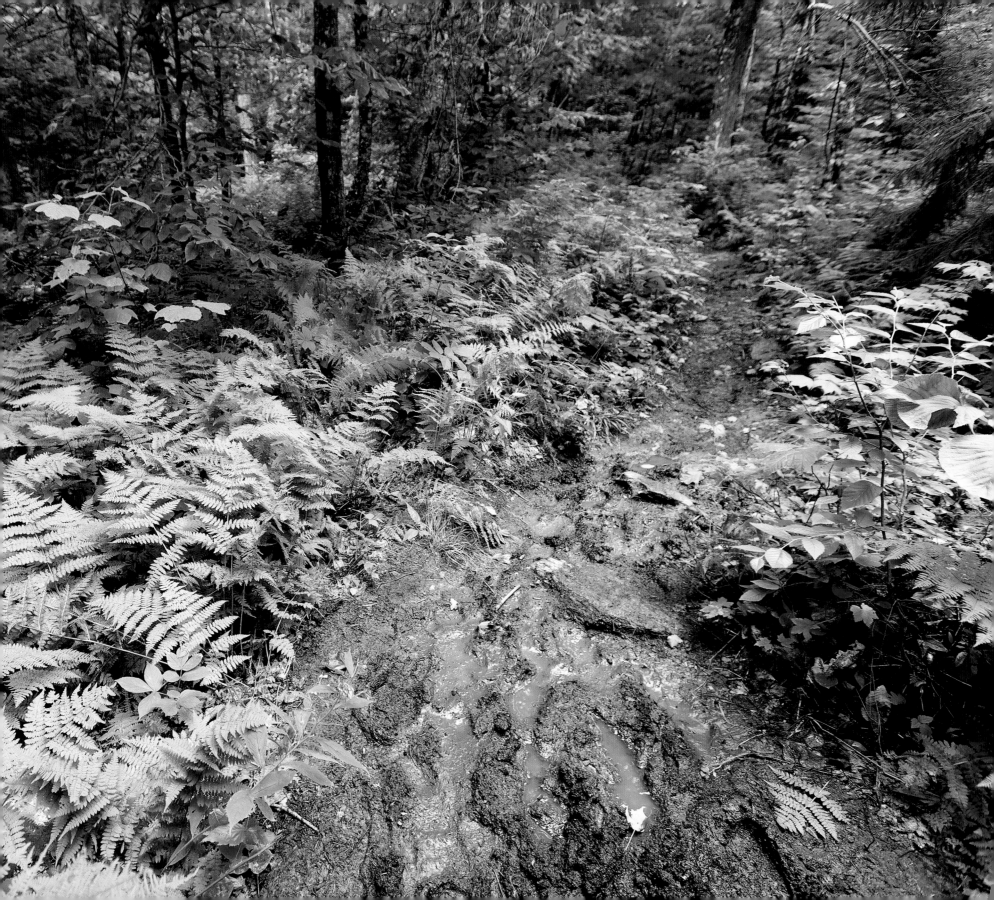

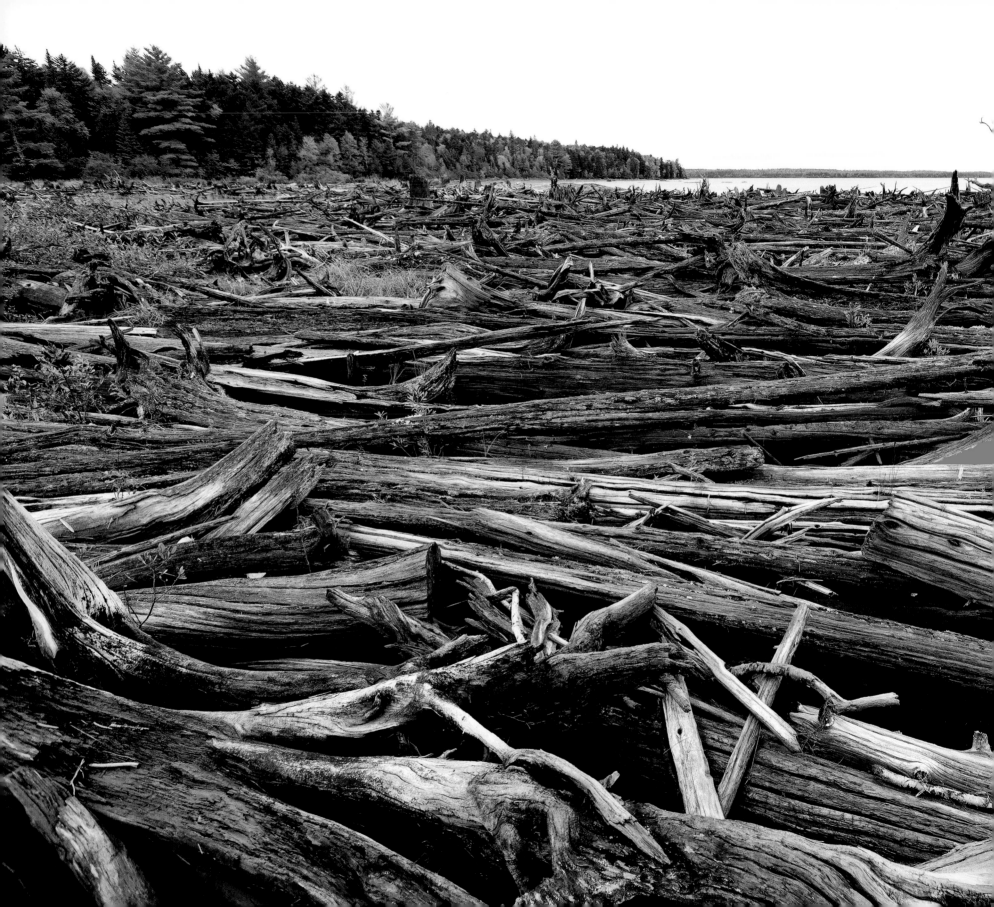

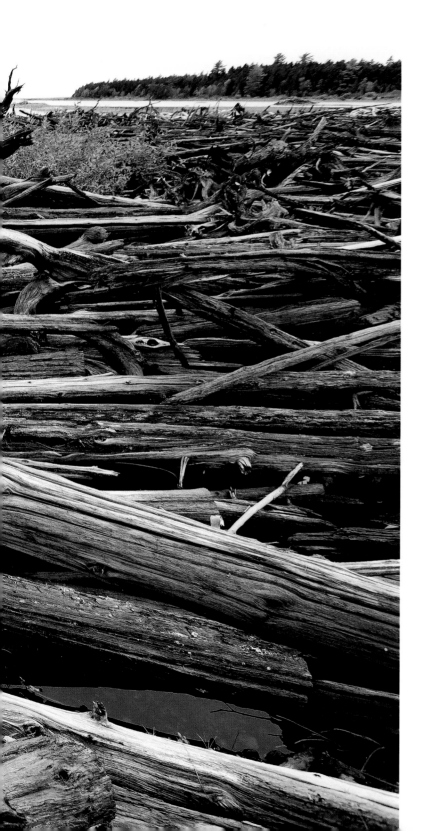

A belt of dead trees stood all around
the lake, some far out in the water, with
others prostrate behind them, and they
made the shore, for the most part, almost
inaccessible. This is the effect of the dam
at the outlet. Thus the natural sandy or
rocky shore, with its green fringe, was
concealed and destroyed.

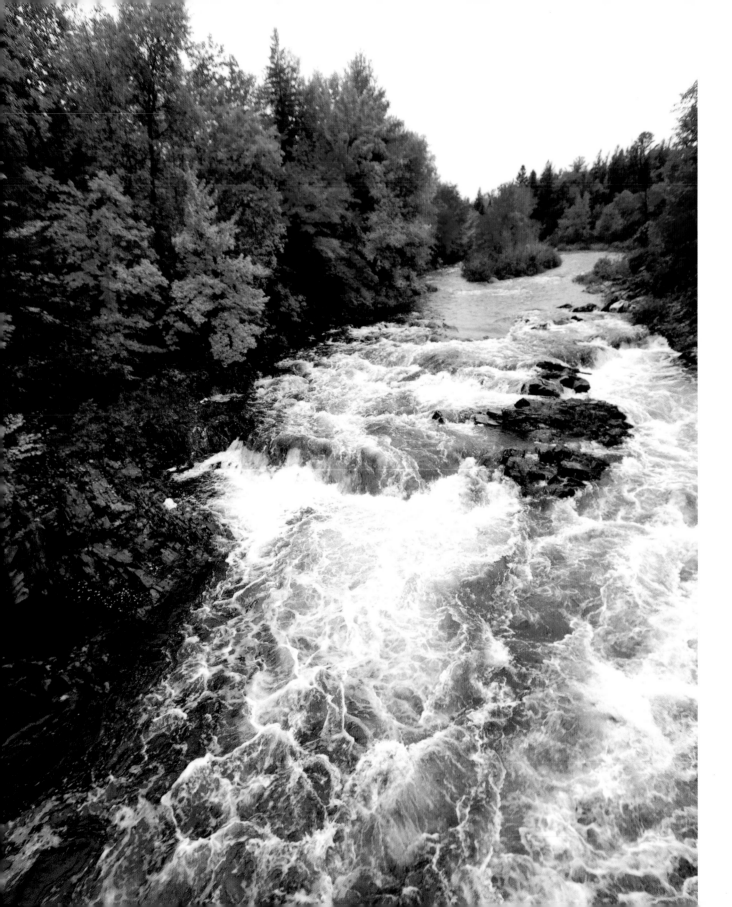

It is exceedingly rapid and rocky . . . and can hardly be considered navigable, unless that may mean that what is launched in it is sure to be carried swiftly down it, though it may be dashed to pieces by the way. It is somewhat like navigating a thunder-spout. With commonly an irresistible force urging you on, you have got to choose your own course each moment, between the rocks and shallows.

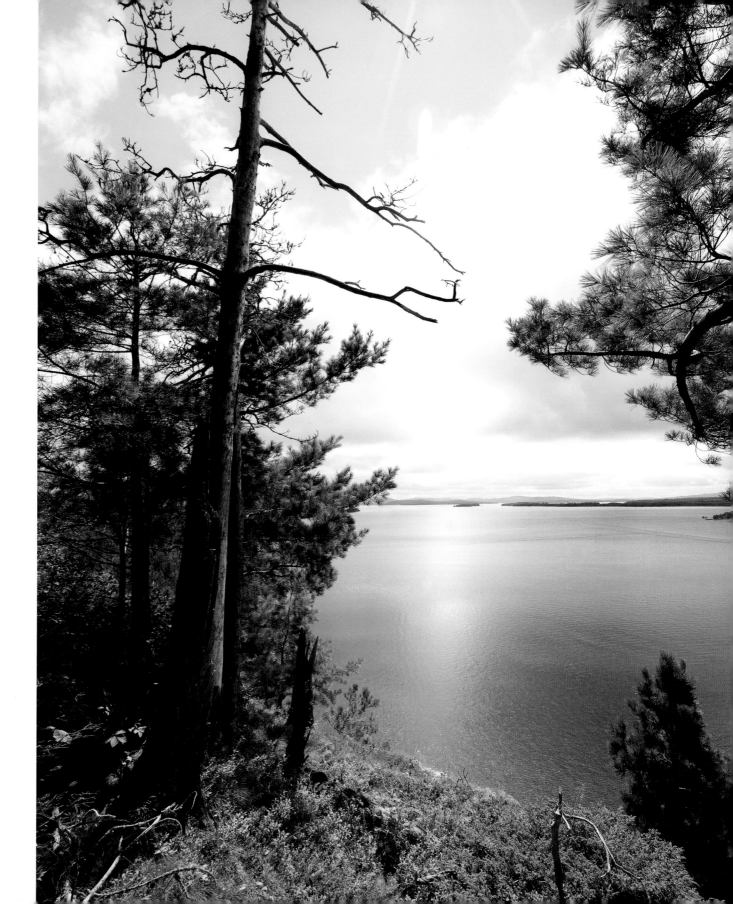

Strange that so few ever come to the woods to see how the pine lives and grows and spires, lifting its evergreen arms to the light,—to see its perfect success; but most are content to behold it in the shape of many broad boards brought to market, and deem *that* its true success! But the pine is no more lumber than man is, and to be made into boards and houses is no more its true and highest use than the truest use of a man is to be cut down and made into manure.

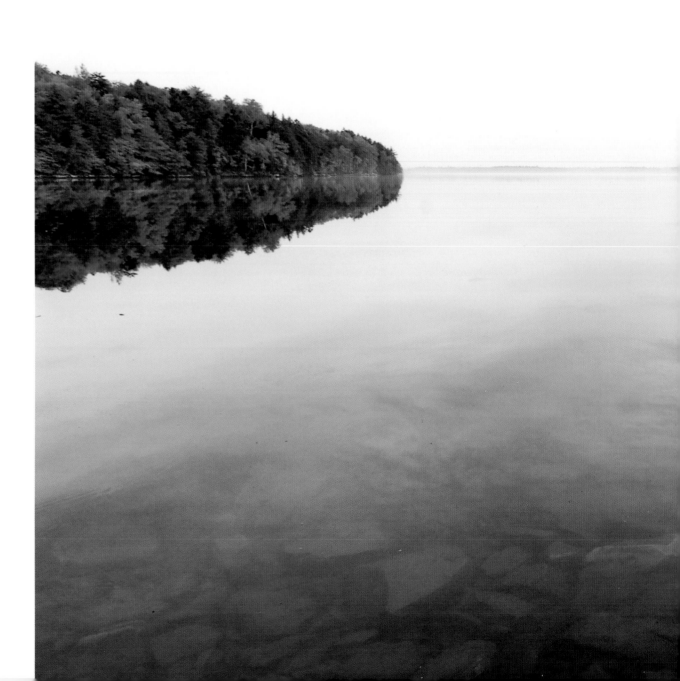

The morning was

a bright one, and perfectly still
and serene, the lake as smooth as
glass, we making the only ripples
as we paddled into it. The dark
mountains about it were seen
through a glaucous mist, and the
brilliant white stems of canoe-
birches mingled with the other
woods around it. The wood-
thrush sang on the distant shore,
and the laugh of some loons,
sporting in a concealed western
bay, as if inspired by the morning,
came distinct over the lake to us,
and, what was remarkable, the
echo which ran round the lake
was much louder than the original
note; probably because, the loons
being in a regularly curving bay
under the mountain, we were
exactly in the focus of many
echoes, the sound being reflected
like light from a concave mirror.

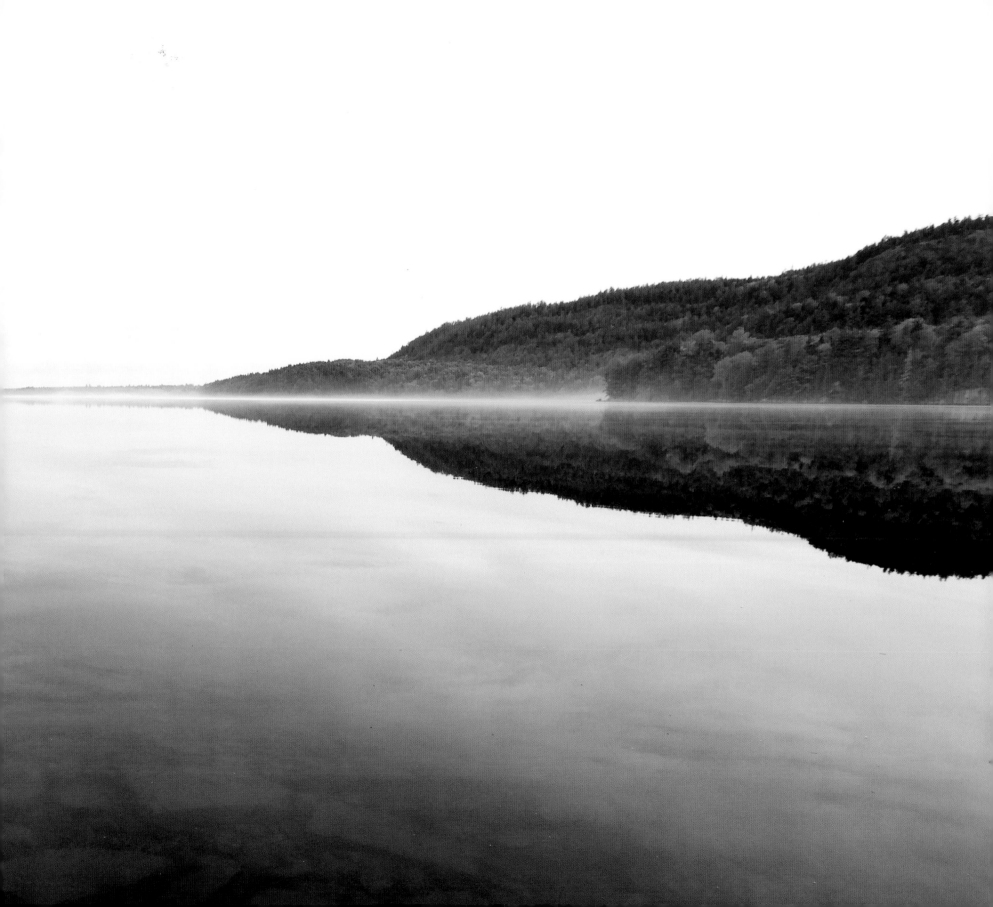

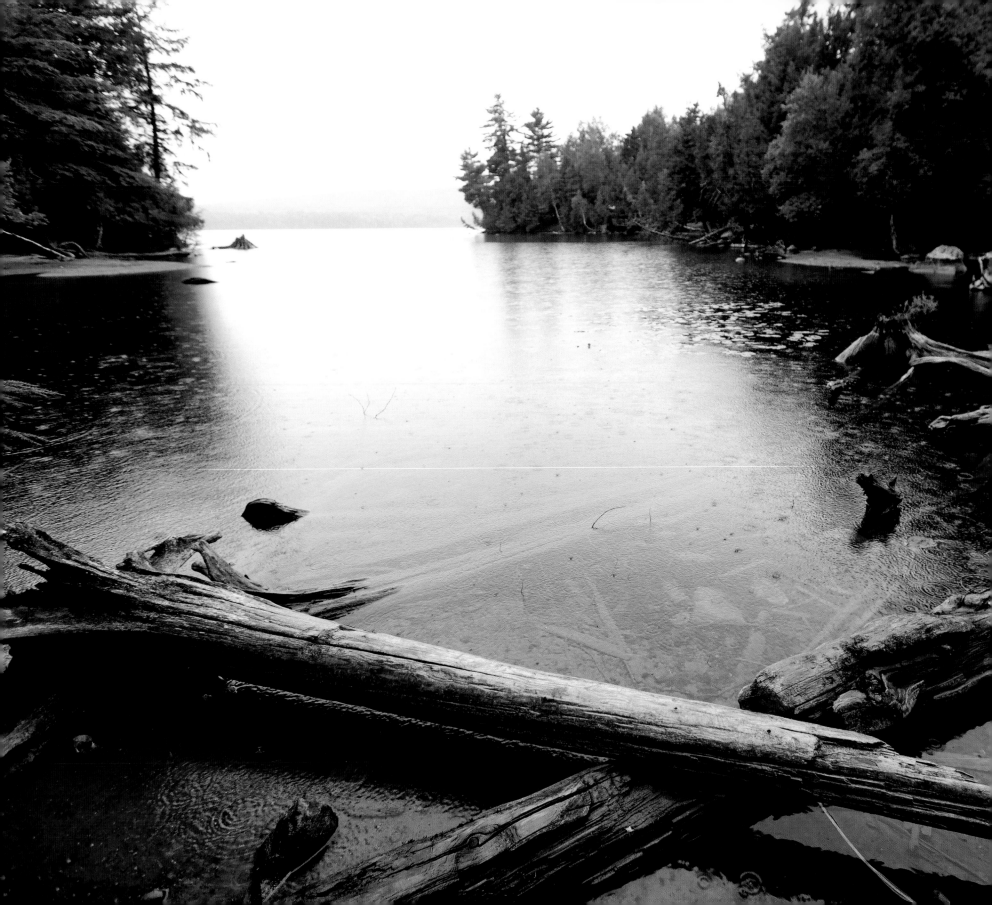

I have often wished since that I was with them. They search for timber over a given section, climbing hills and often high trees to look off,—explore the streams by which it is to be driven, and the like,—spend five or six weeks in the woods, alone, a hundred miles or more from any town,—roaming about, and sleeping on the ground where night overtakes them,—depending chiefly on the provisions they carry with them, though they do not decline what game they come across,—and then in the fall they return and make report to their employers, determining the number of teams that will be required the following winter. Experienced men get three or four dollars a day for this work. It is a solitary and adventurous life, and comes nearest to that of a trapper of the West, perhaps. They work ever with a gun as well as an axe, let their beards grow, and live without neighbors, not on an open plain, but far within a wilderness.

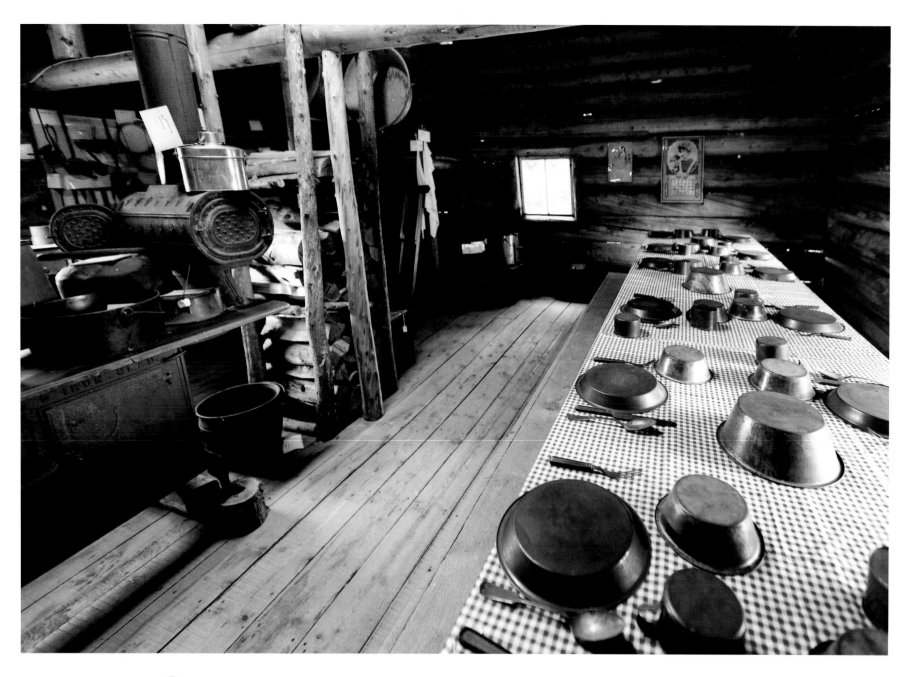

Supper was got before our eyes in the ample kitchen, by
a fire which would have roasted an ox; many whole logs, four
feet long, were consumed to boil our tea-kettle.

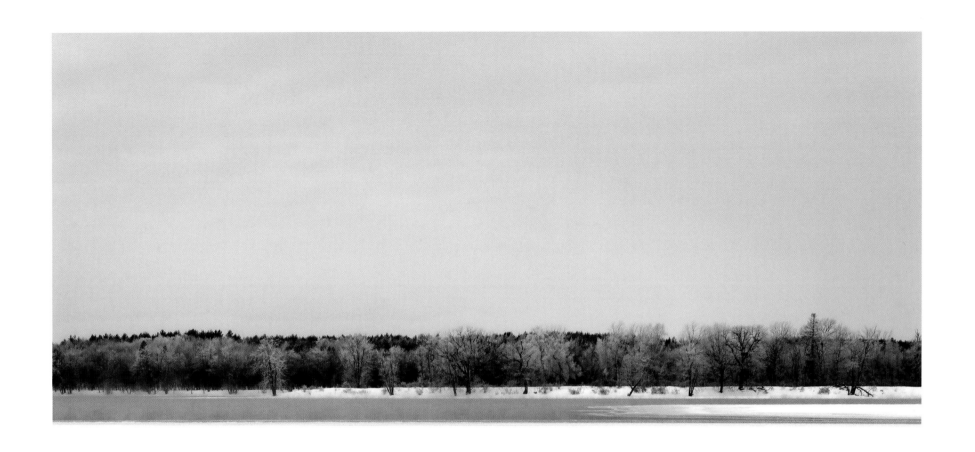

In the winter, however, which is very equable and long, the ice is the great highway
. . . . Imagine the solitary sled-track running far up into the snowy and evergreen
wilderness, hemmed in closely for a hundred miles by the forest, and again stretching
straight across the broad surfaces of concealed lakes!

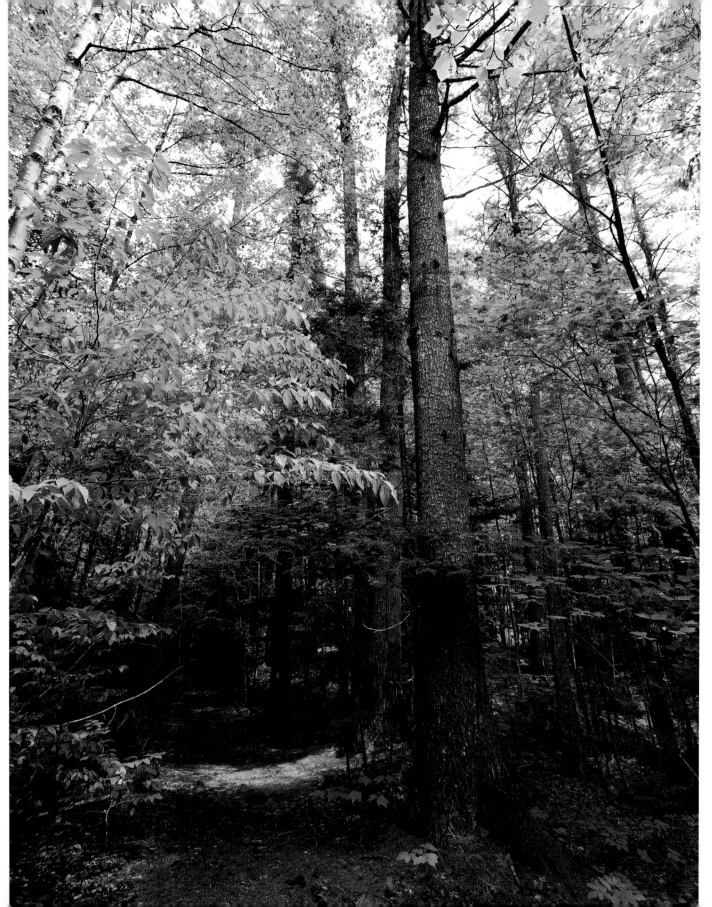

The spruce
and fir trees
crowded to
the track on
each side to
welcome us.

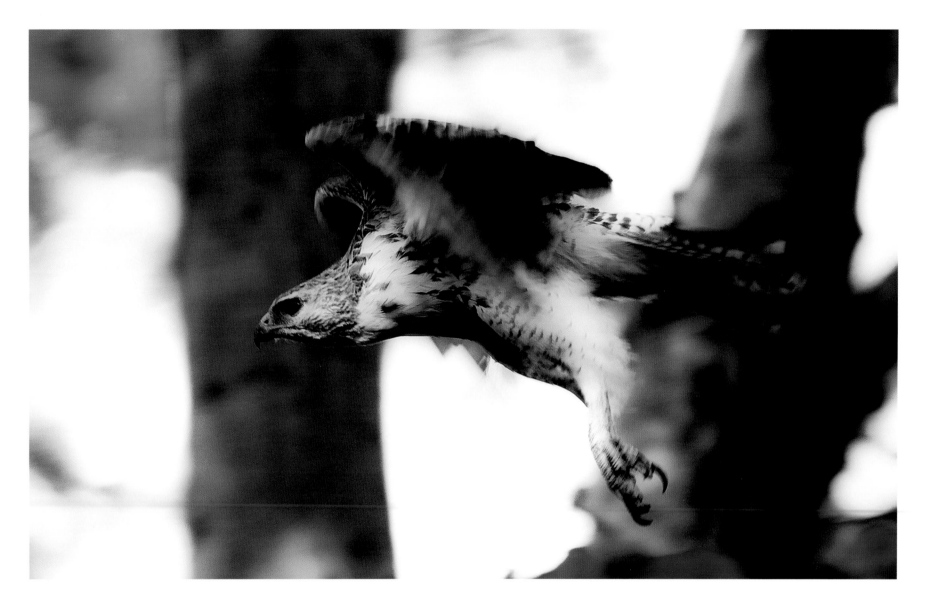

We drove the fish-hawk from perch to perch,

each time eliciting a scream or whistle, for many miles before us.

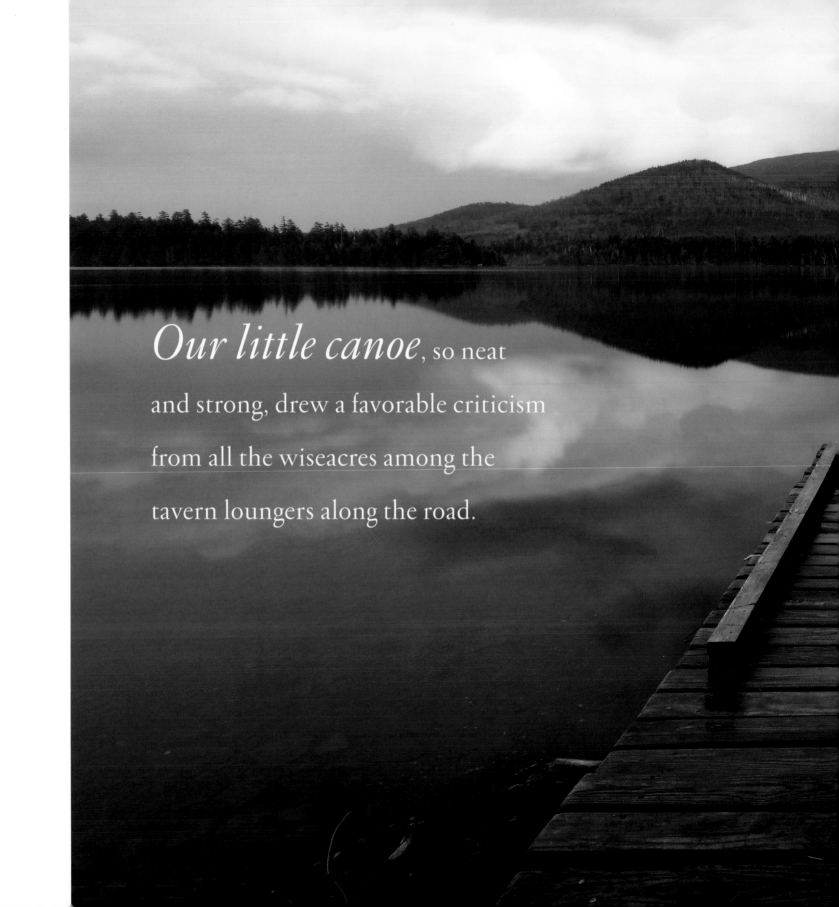

Our little canoe, so neat and strong, drew a favorable criticism from all the wiseacres among the tavern loungers along the road.

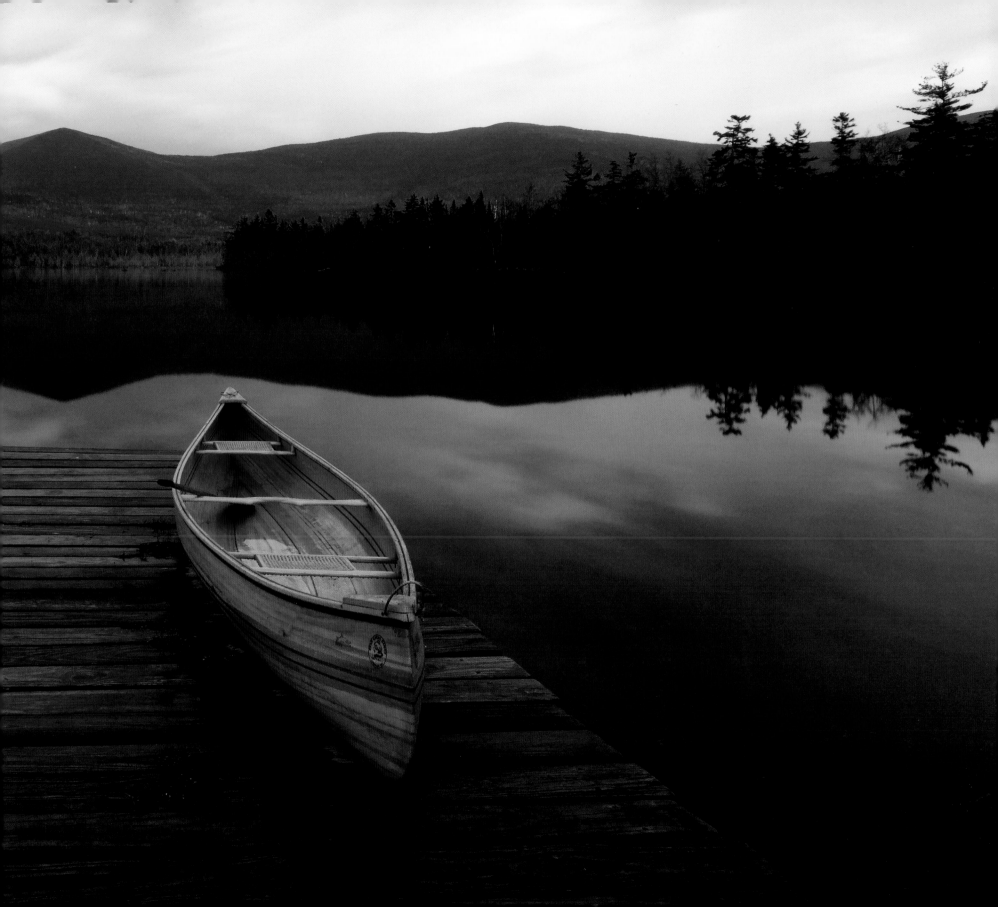

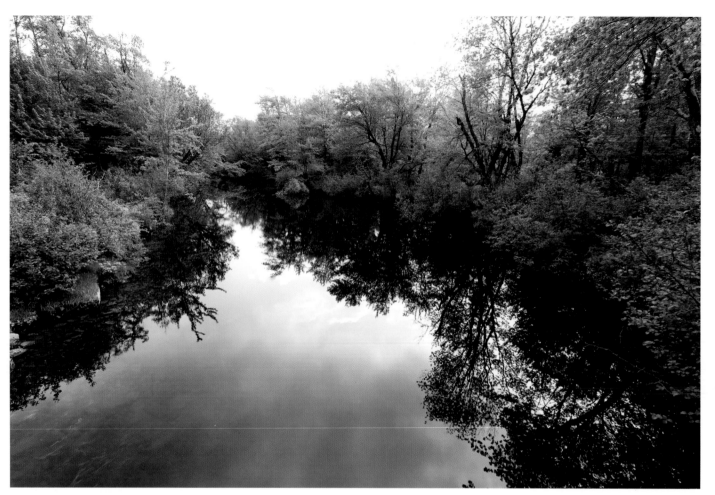

Two steps from the water on either side, and you come to the abrupt bushy and rooty if not turfy edge of the bank, four or five feet high, where the interminable forest begins, as if the stream had but just cut its way through it.

Things are quite changed since I was here eleven years ago. Where there were but one or two houses, I now found quite a village, with sawmills and a store (the latter was locked, but its contents were so much the more safely stored), and there was a stage-road to Mattawamkeag, and the rumor of a stage. Indeed, a steamer had ascended thus far once, when the water was very high.

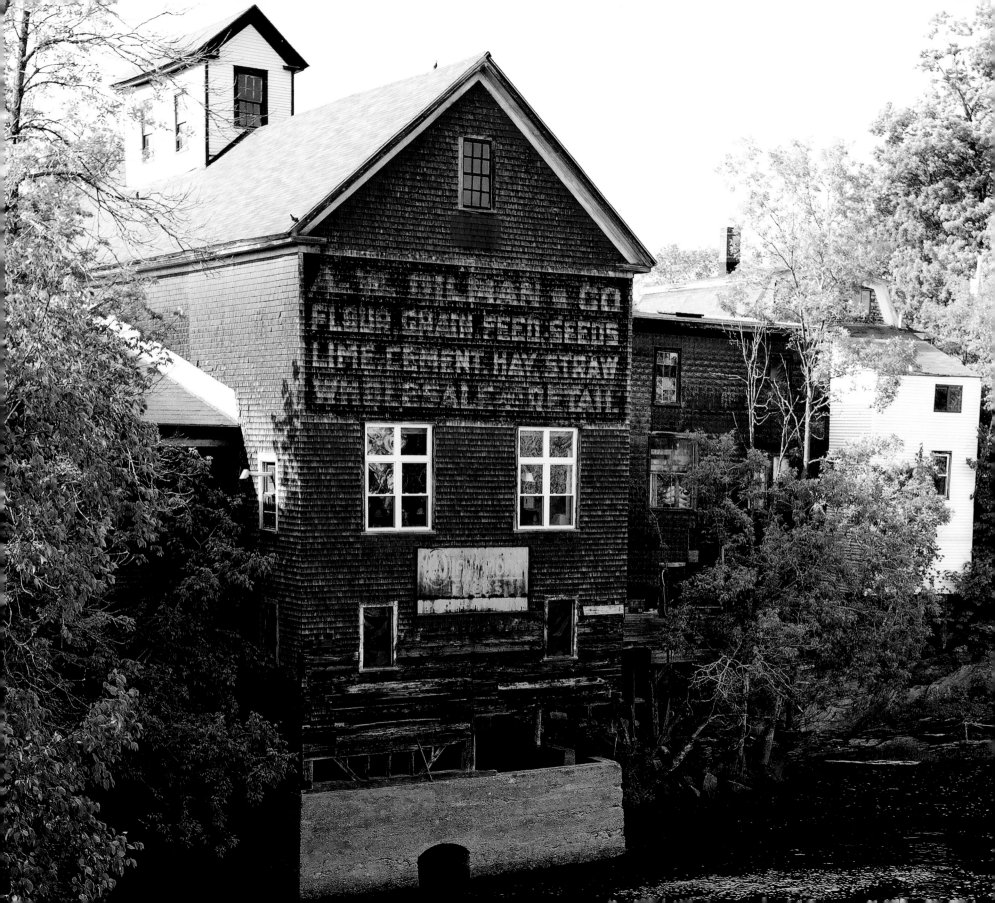

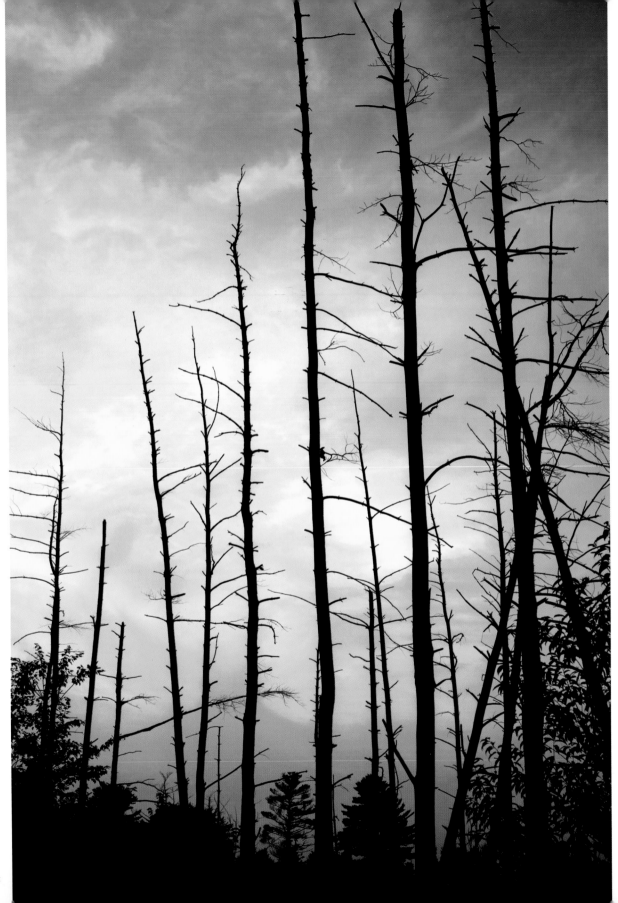

It is difficult to conceive of a region uninhabited by man. We habitually presume his presence and influence everywhere. And yet we have not seen pure Nature, unless we have seen her thus vast and drear and inhuman. Nature was here something savage and awful, though beautiful.

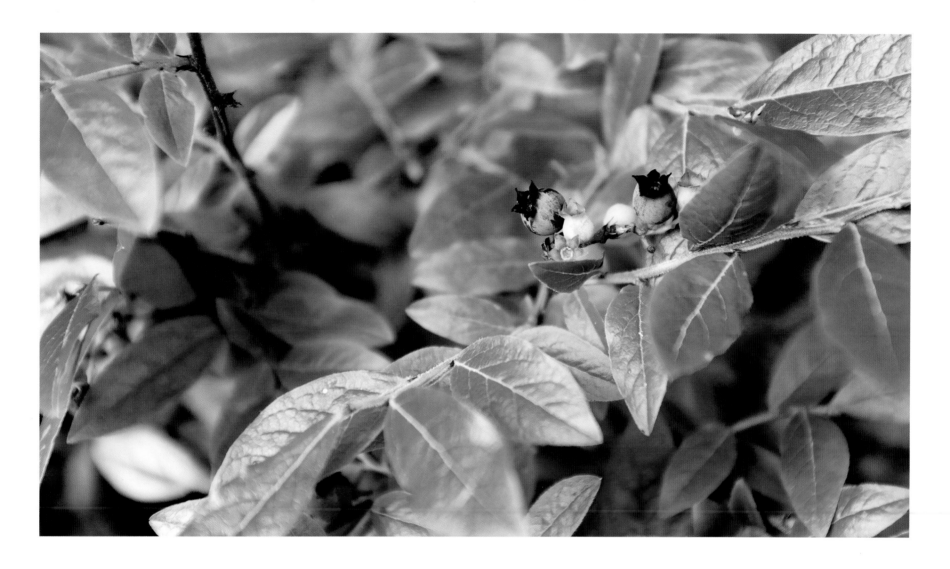

Blueberries were distributed along our whole route; and in one place the bushes were drooping with the weight of the fruit, still as fresh as ever. It was the 7th of September. Such patches afforded a grateful repast, and served to bait the tired party forward. When any lagged behind, the cry of "blue-berries" was most effectual to bring them up.

But nothing
could exceed the
toughness of the twigs,
—not one snapped
under my weight, for
they had slowly grown.

In shooting the rapids, the boatman has this problem to solve: to choose a circuitous and safe course amid a thousand sunken rocks, scattered over a quarter or half a mile, at the same time that he is moving steadily on at a rate of fifteen miles an hour. Stop he cannot; the only question is where will he go.

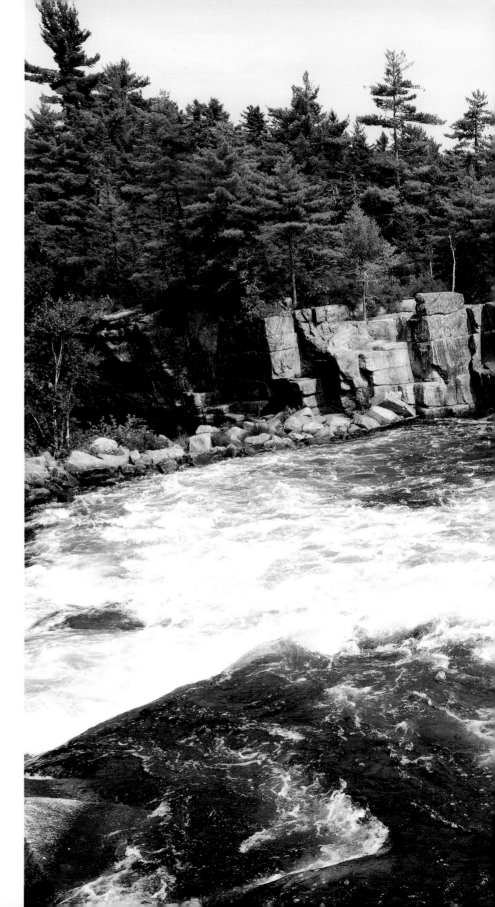

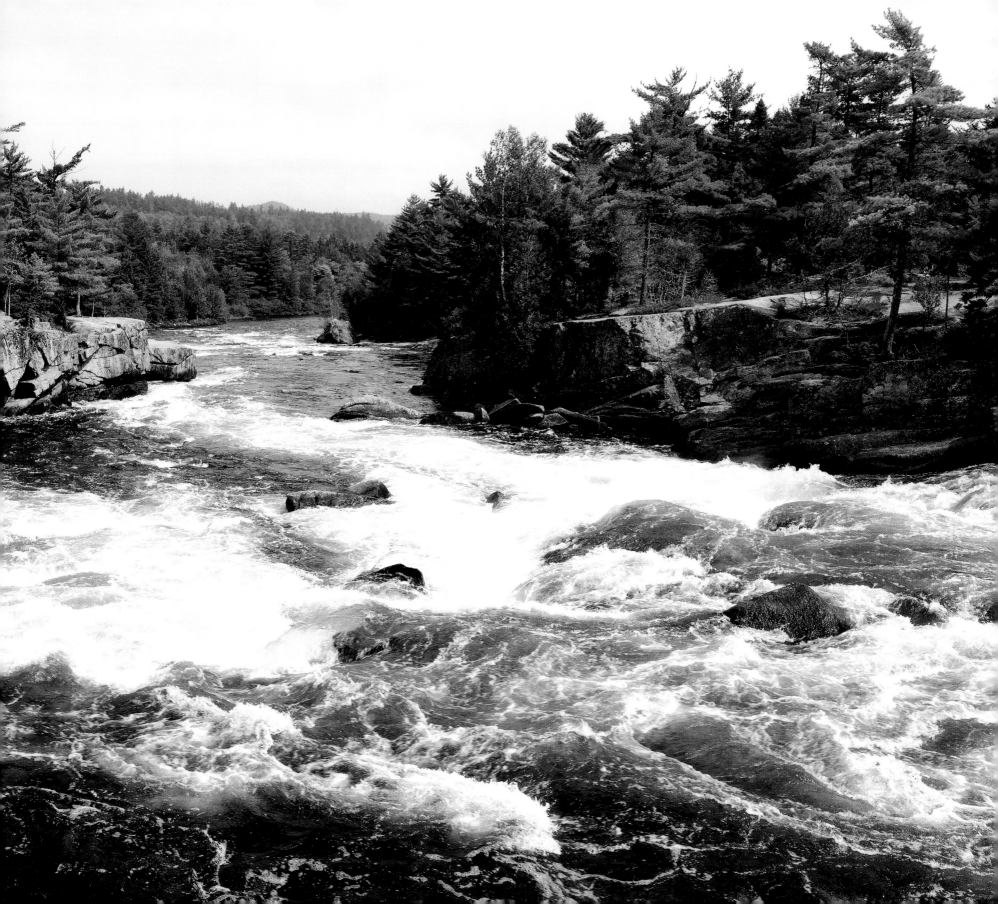

The evergreen woods had a decidedly sweet and bracing fragrance; the air was a sort of diet-drink.

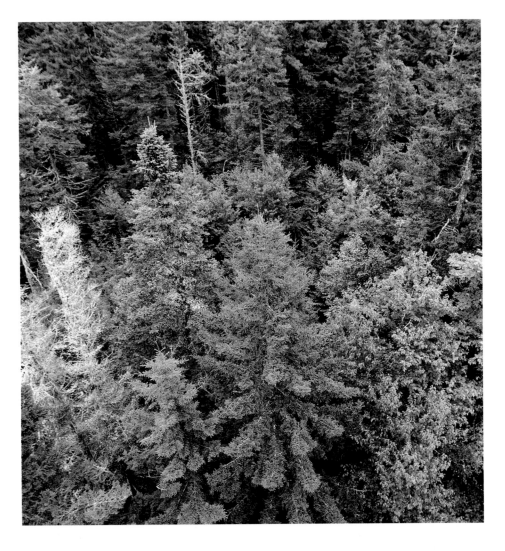

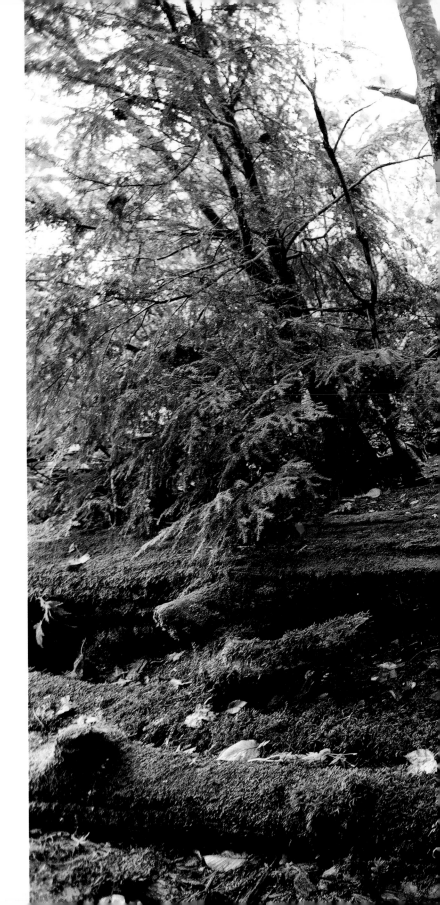

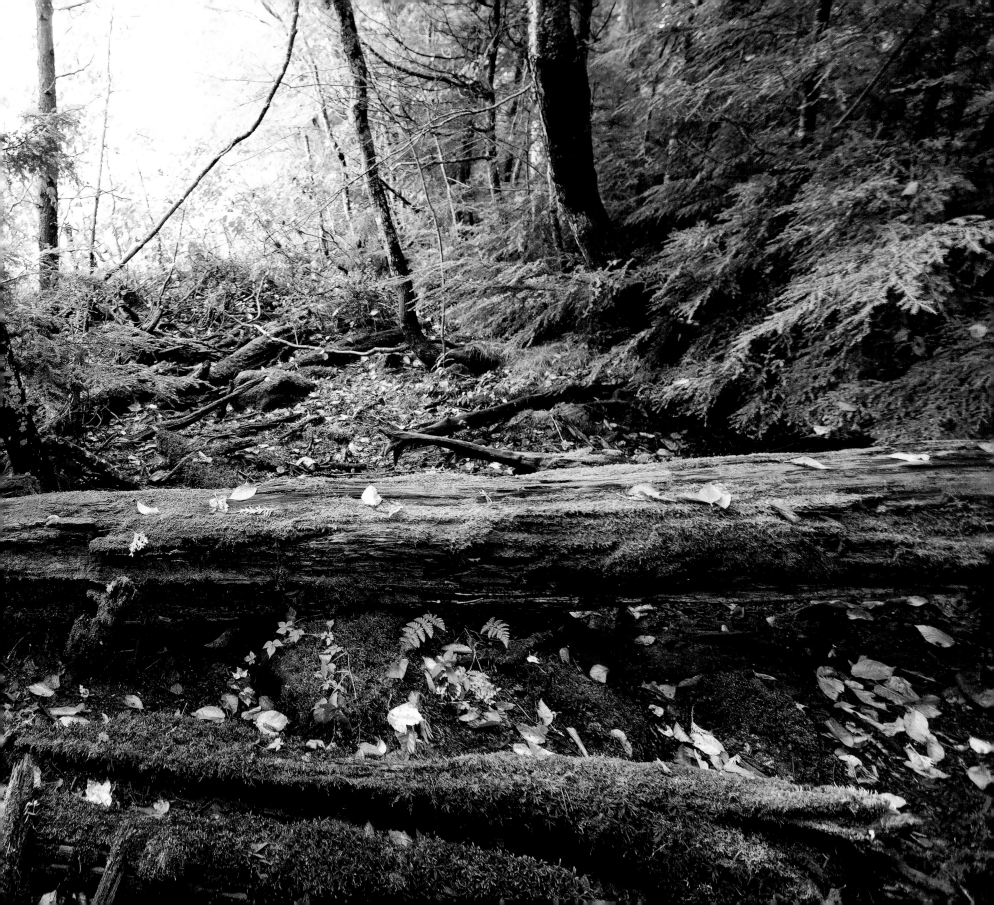

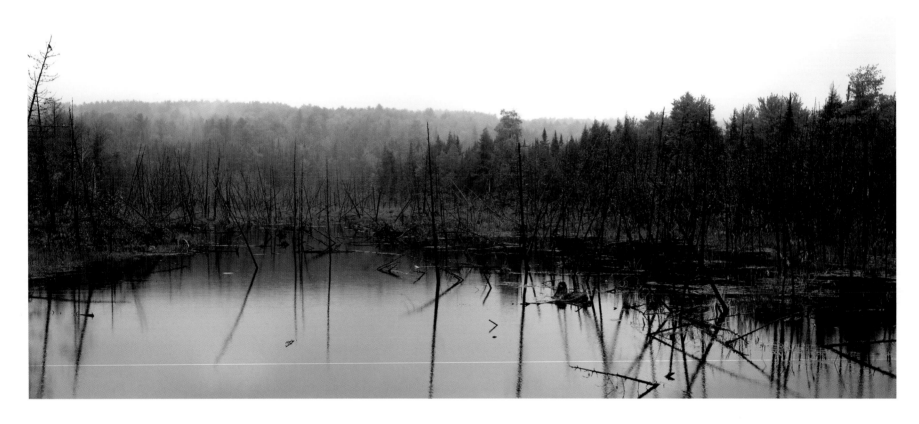

While we were getting breakfast a brood of twelve black dippers, half grown, came paddling by within three or four rods, not at all alarmed; and they loitered about as long as we stayed, now huddled close together, within a circle of eighteen inches in diameter, now moving off in a long line, very cunningly.

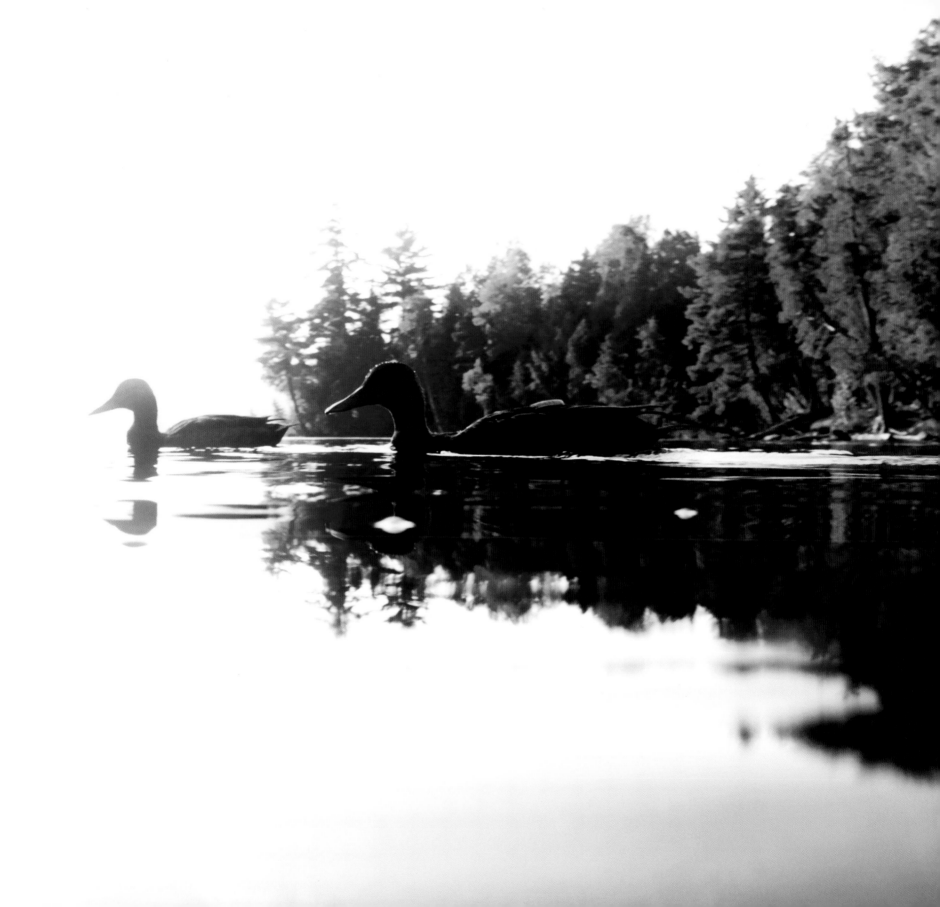

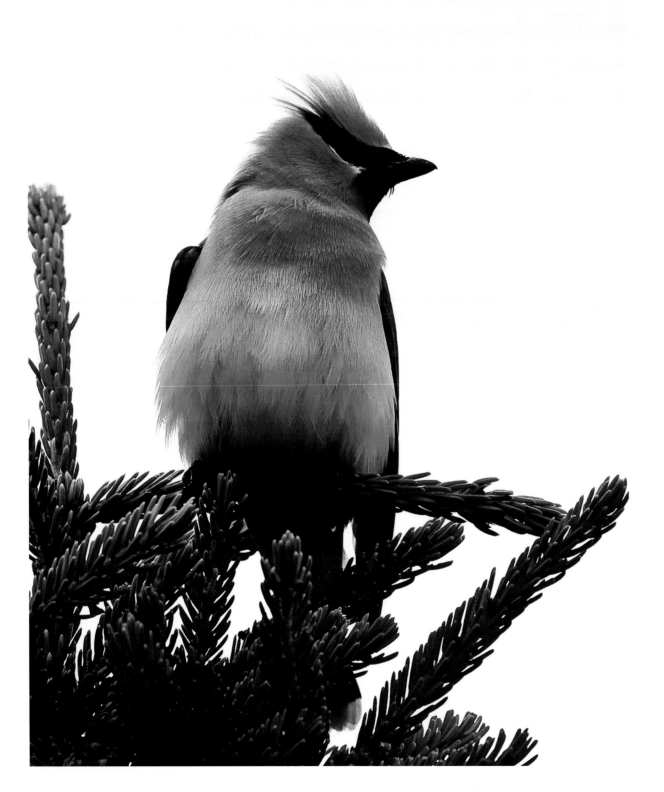

Here was traveling
of the old heroic kind
over the unaltered
face of nature.

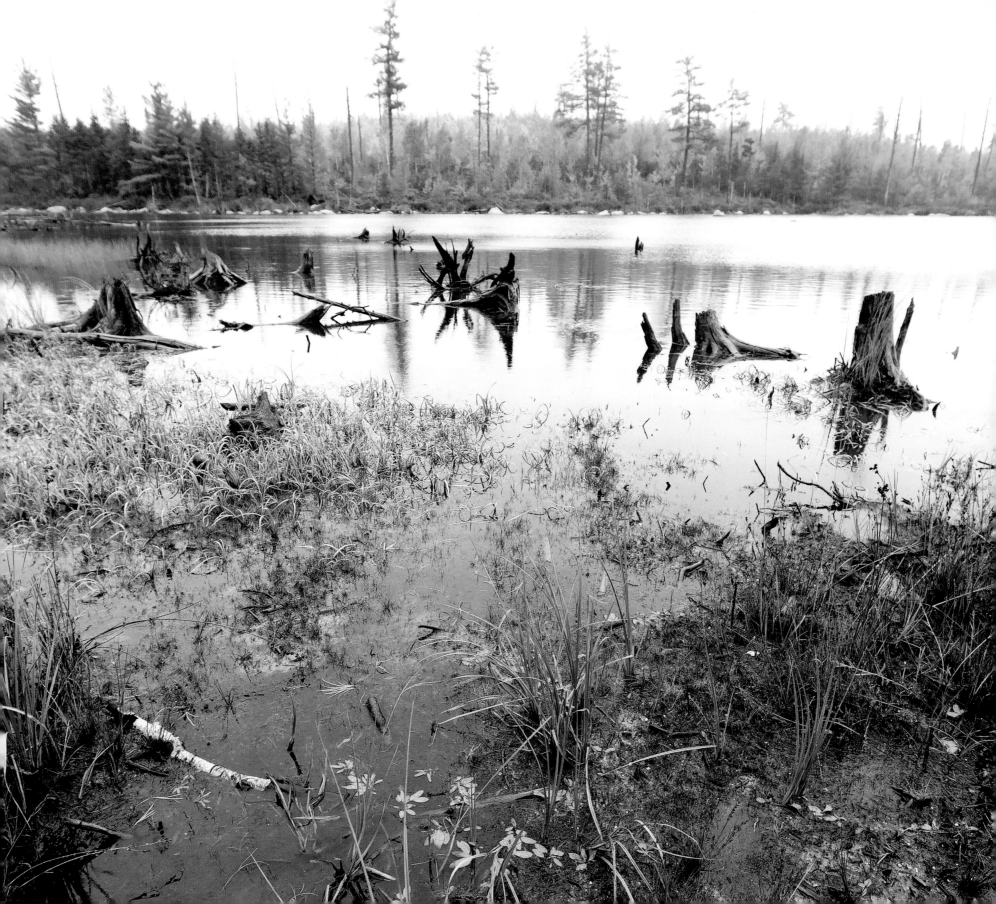

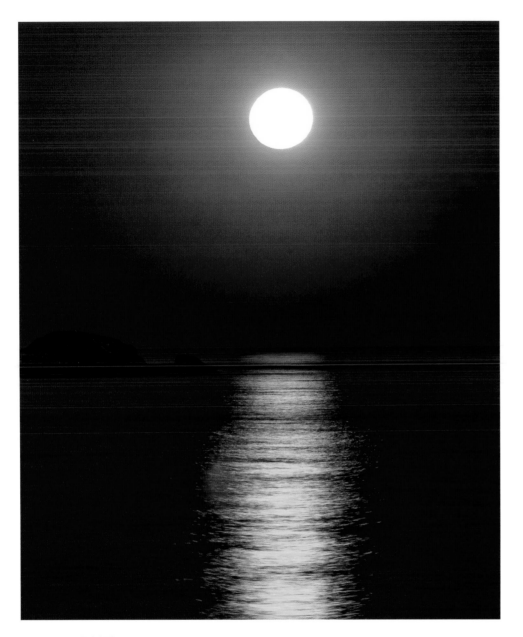

He who rides and keeps the beaten

track studies the fences chiefly.

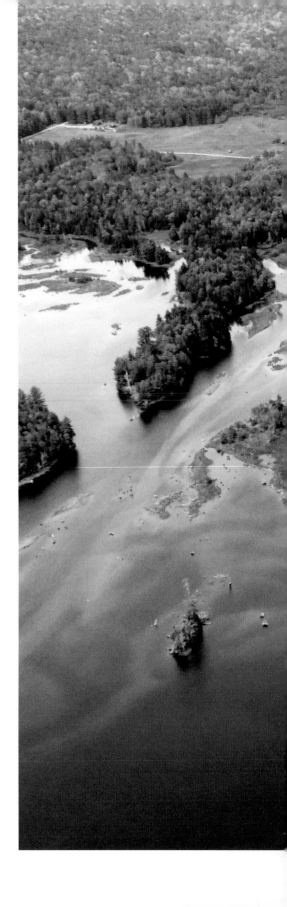

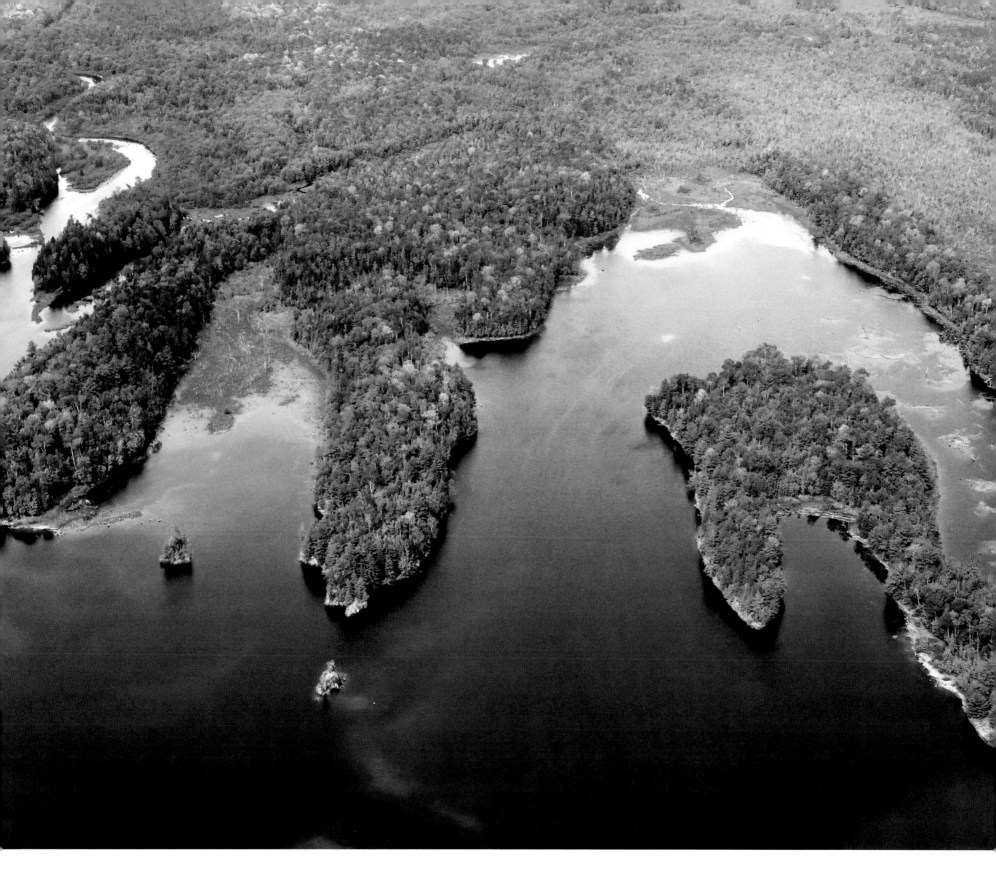

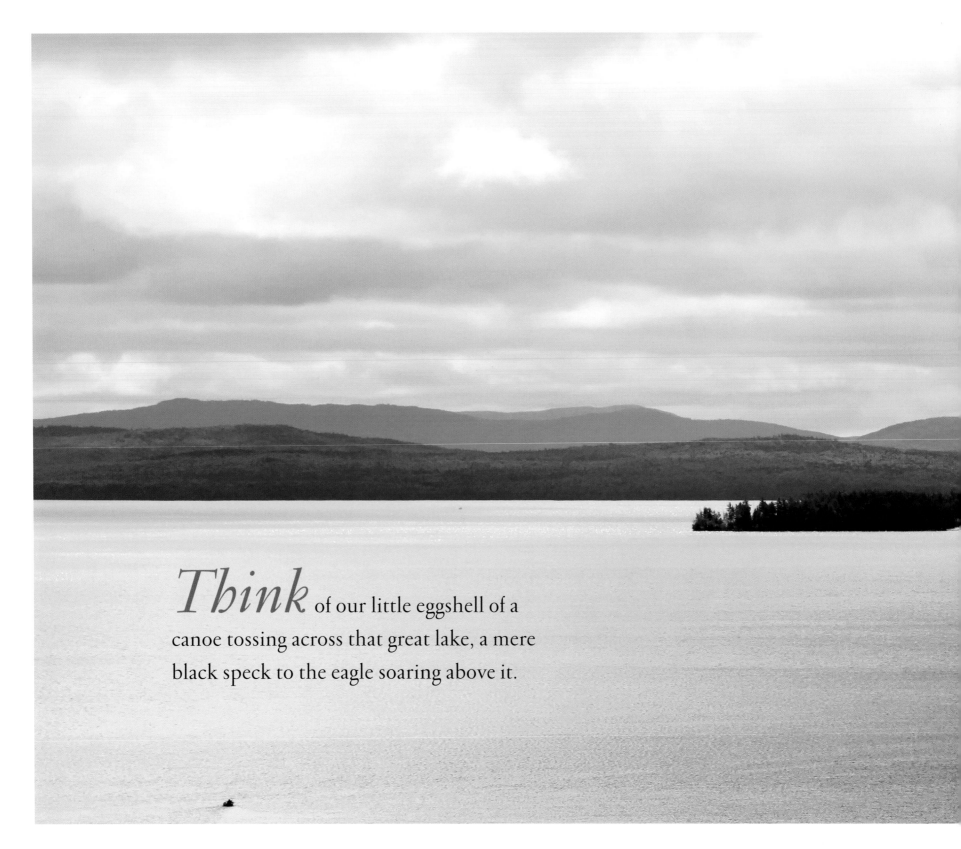

Think of our little eggshell of a canoe tossing across that great lake, a mere black speck to the eagle soaring above it.

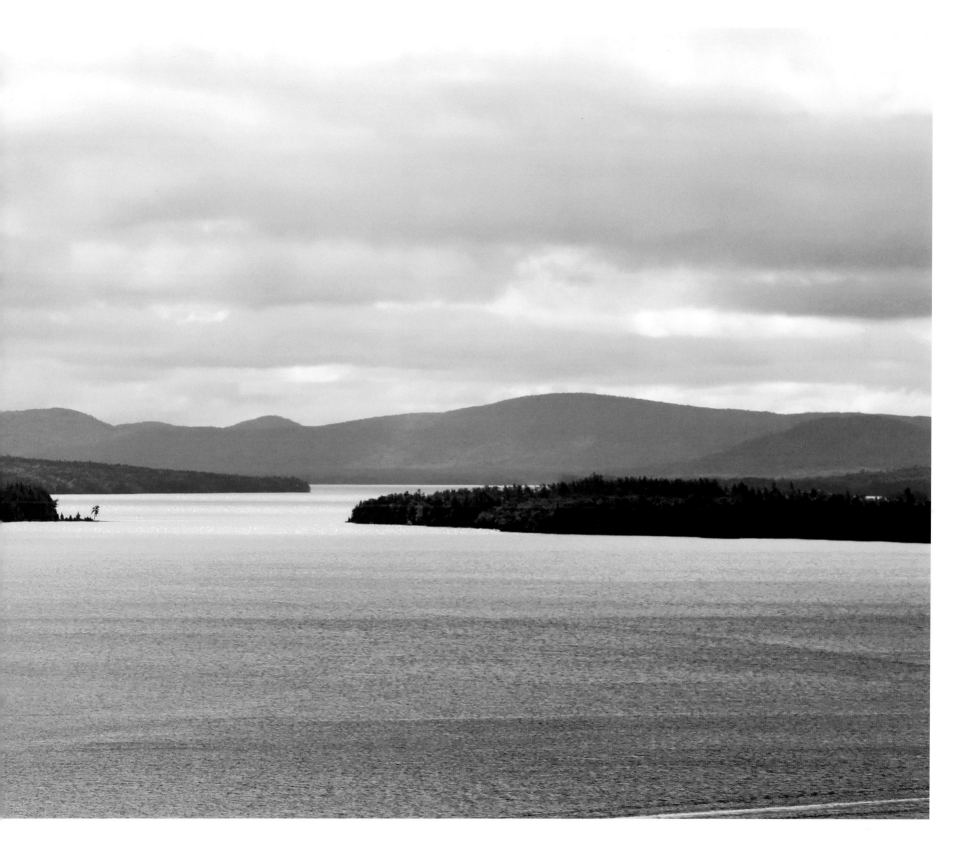

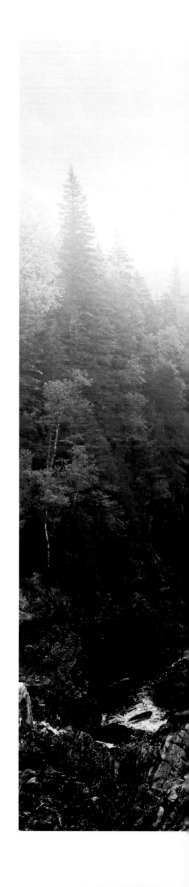

Here was no man's garden, but the unhandselled globe. It was not lawn, nor pasture, nor mead, nor woodland, nor lea, nor arable, nor wasteland. It was the fresh and natural surface of the planet Earth, as it was made for ever and ever,—to be the dwelling of man, we say,—so Nature made it, and man may use it if he can. Man was not to be associated with it. It was Matter, vast, terrific,—not his Mother Earth that we have heard of, not for him to tread on, or be buried in,—no, it were being too familiar even to let his bones lie there,—the home, this, of Necessity and Fate. There was there felt the presence of a force not bound to be kind to man.

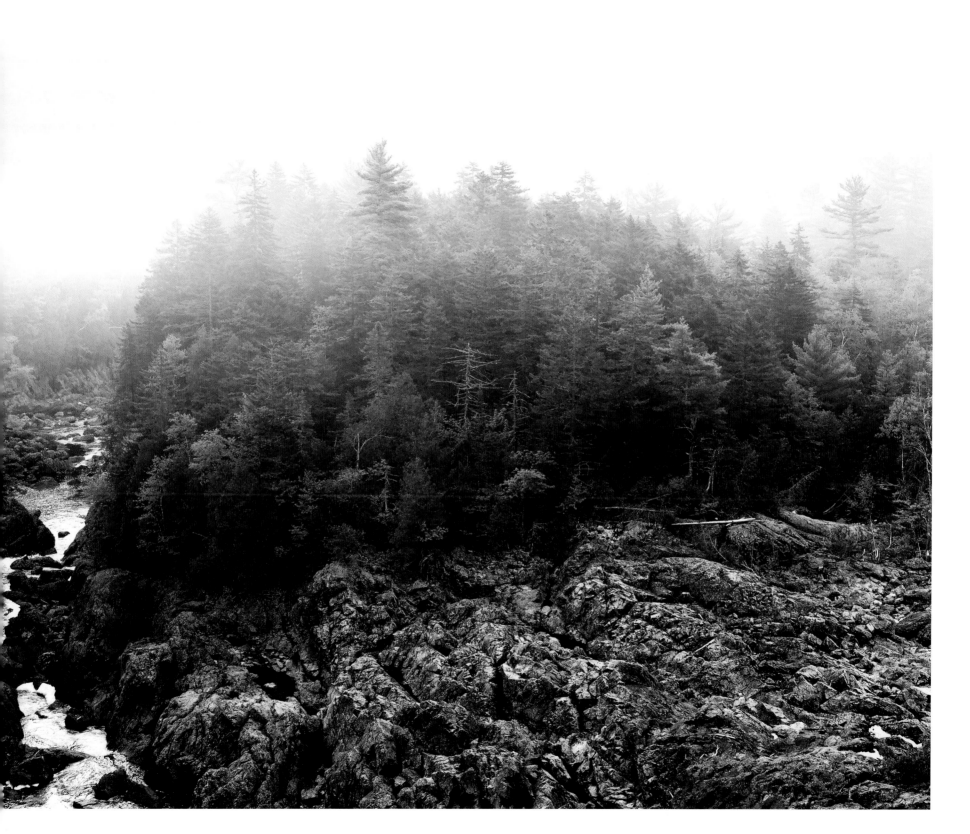

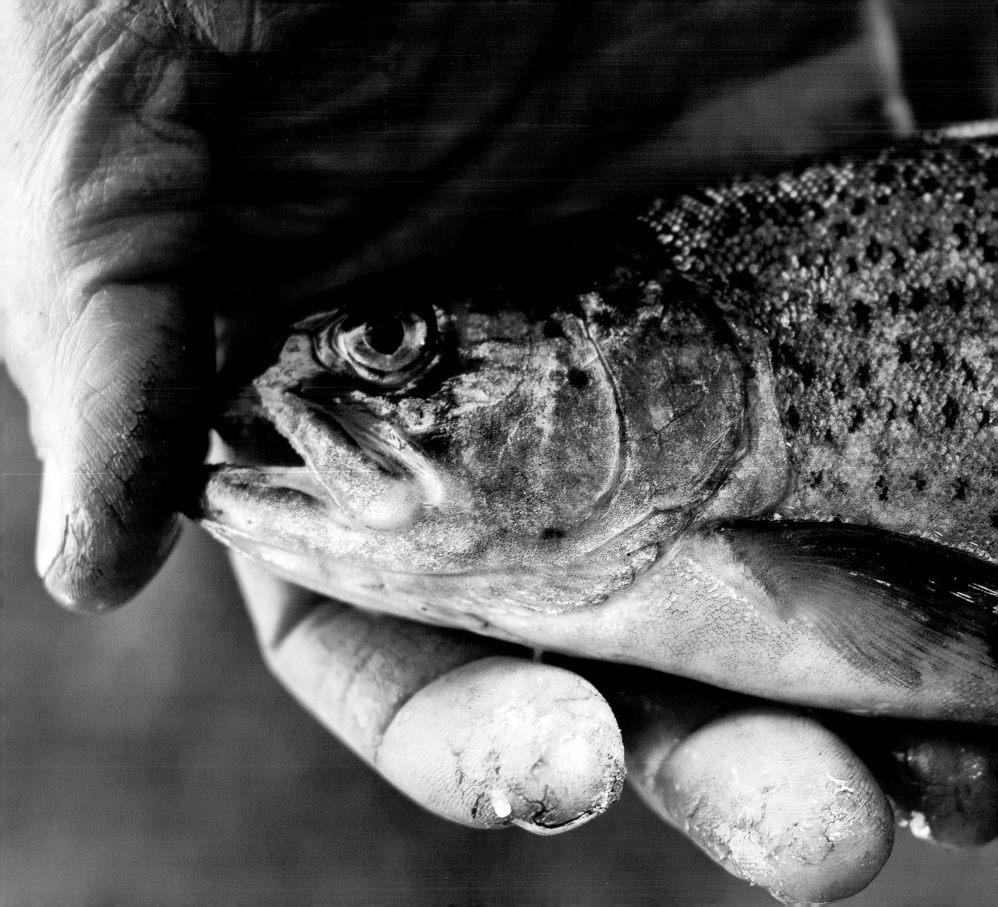

In the night I dreamed of trout-fishing; and, when at length I awoke, it seemed a fable that this painted fish swam there so near my couch, and rose to our hooks the last evening, and I doubted if I had not dreamed it all. So I arose before dawn to test its truth, while my companions were still sleeping. . . . Standing on the shore, I once more cast my line into the stream, and found the dream to be real and the fable true.

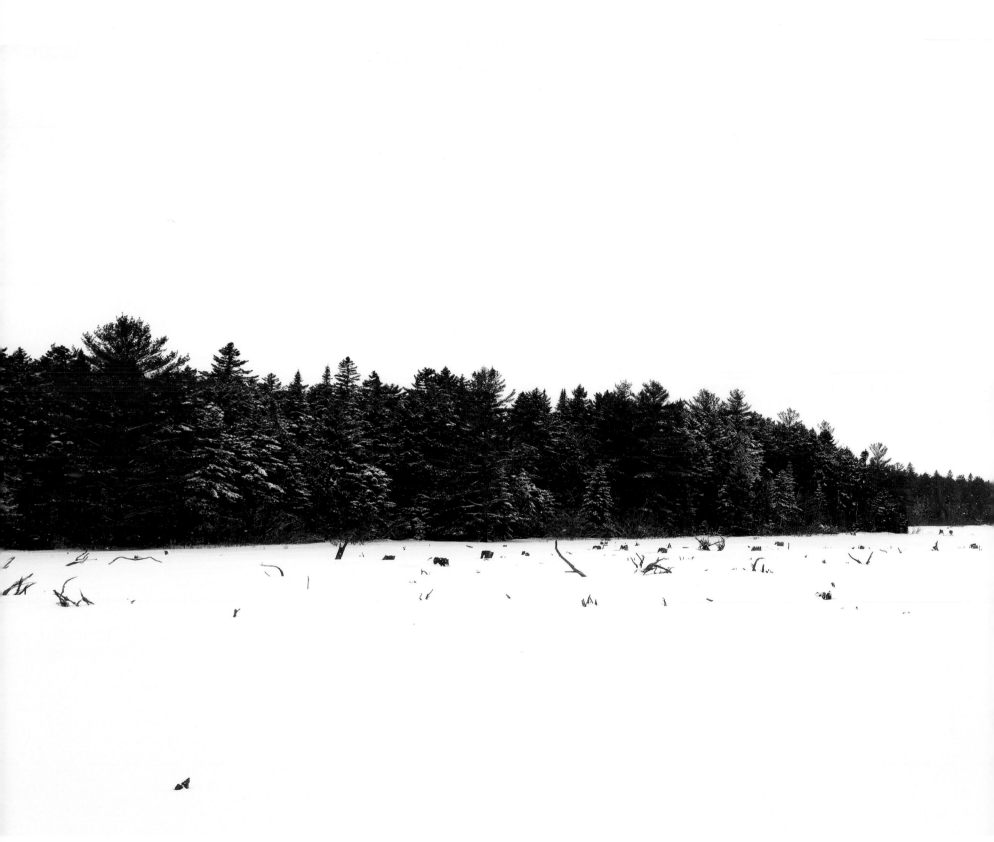

What a wilderness walk for a man to take alone!
None of your half-mile swamps, none of your mile-wide woods merely, as
on the skirts of your towns, without hotels, only a dark mountain or a lake
for guide-board and station, over ground much of it impassable in summer.

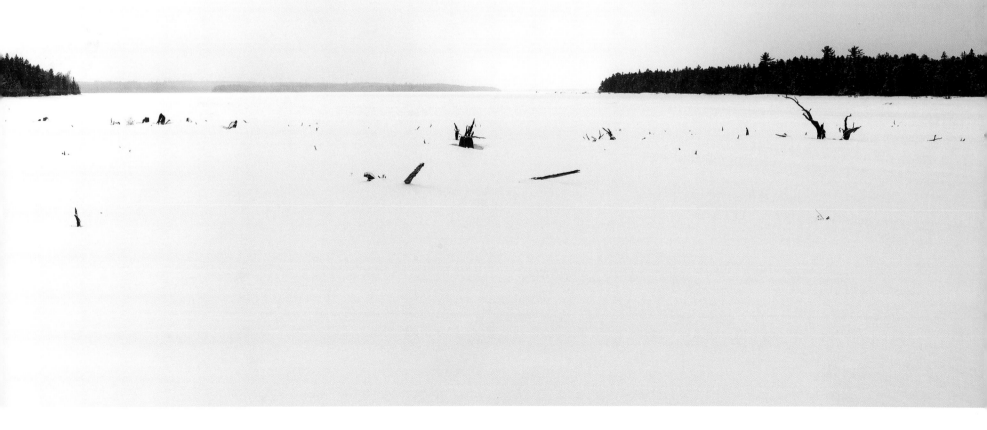

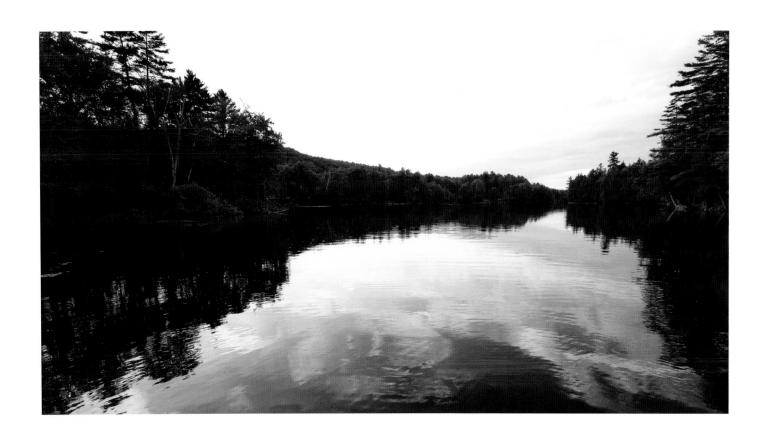

Acknowledgements

I am grateful for the help of many people. I especially want to thank my kids Jared and Caitie and their mom Anne Marie for allowing me the time to complete this project.

I also want to thank my friend and fellow photographer, Eric Alexander. He accompanied me on most of the journey, sacrificing a substantial amount of time with his family. He also forded the same rivers, fell into the same snow drifts, slept on the same hard ground, and was pestered by the same insects.

I can't say enough about the people of Maine who opened their doors to me. The book would not have been possible without their hospitality; especially the Lumberman's Museum in Patten and the Maine Forest and Logging Museum, located in Bradley. Both institutions do an excellent job of preserving a unique part of Maine history.

Thanks also to Jim Strang of Katahdin Air, who flew us around the back country; my friend Bill, for his assistance with the trout pictures; Eric Stirling, his mother, Carol, his wife, Mildred, and their daughter, Avis Clare, of West Branch Pond Camps for permission to photograph anything I found interesting and for the great stories around the kitchen table. And thanks, too, to the staff at The Birches on Moosehead Lake, especially Steve Sullivan and his son, Evan, who helped us navigate the back country in search of moose.

A big thank you to the boys at Scooters, for putting a new alternator in my truck one Saturday morning instead of going to the wheely races. I might still be stuck up off the Golden Road.

Lastly to my parents. I fell in love with photography when I was a boy and they let me run with it. And to Mike Steere and Down East Books. They looked at my work and decided my parents might have made a wise decision.